SAY IT
with
PAPER

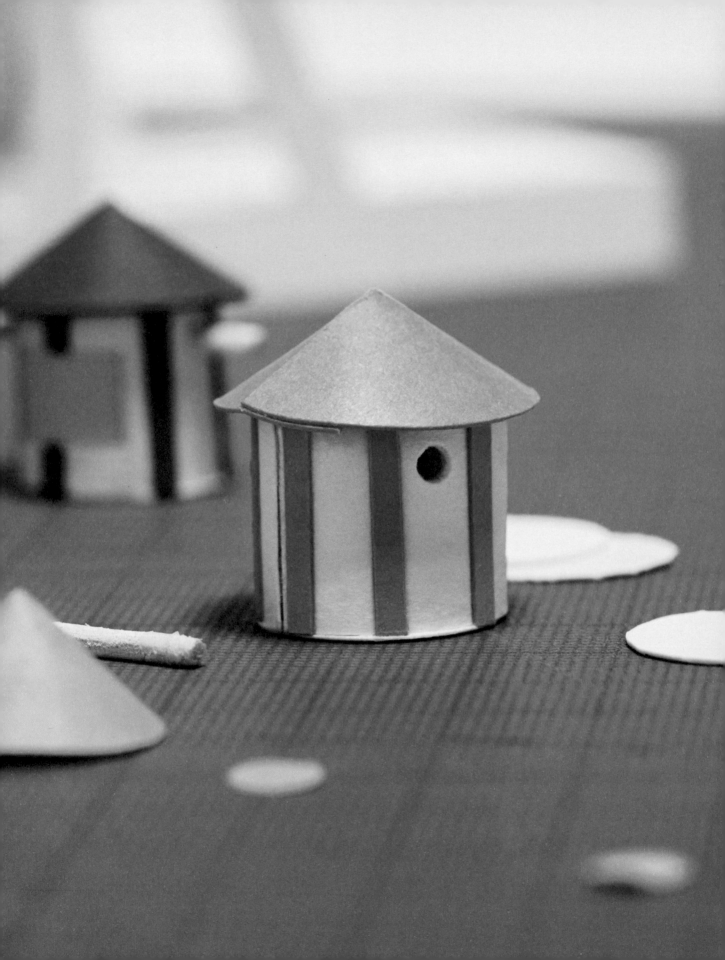

SAY IT
with
PAPER

(FUN PAPERCRAFT PROJECTS
TO CUT, FOLD, AND CREATE)

HATTIE NEWMAN

ilex

An Hachette UK Company
www.hachette.co.uk

First published in the United Kingdom in 2018 by
ILEX, a division of Octopus Publishing Group Ltd
Octopus Publishing Group
Carmelite House
50 Victoria Embankment
London, EC4Y 0DZ
www.octopusbooks.co.uk
www.octopusbooksusa.com

Distributed in the US by Hachette Book Group
1290 Avenue of the Americas
4th and 5th Floors
New York, NY 10104

Distributed in Canada by Canadian Manda Group
664 Annette St., Toronto, Ontario
Canada M6S 2C8

Publisher: Roly Allen
Editorial Director: Helen Rochester
Managing Editor: Frank Gallaugher
Project Editor: Natalia Price-Cabrera
Publishing Assistant: Stephanie Hetherington
Art Director: Julie Weir
Concept and Book Design: Polytechnic
Production Controller: Katie Jarvis

ISBN 978-1-78157-531-4

A CIP catalog record for this book is available
from the British Library

Printed and bound in China

10 9 8 7 6 5 4 3 2 1

CONTENTS

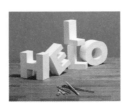
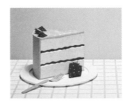
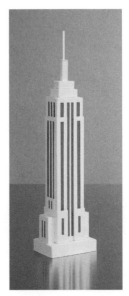
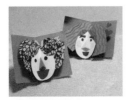

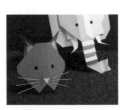
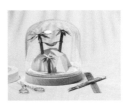
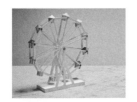
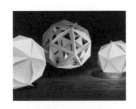

INTRODUCTION

Be honest, do you ever take paper for granted? I think we all do sometimes! Even in our digital age, it still brings us the bill, gets our letters from A to B, and dries our tears. But it's paper's creative scope that fascinates me. For centuries artists have been patiently unfolding paper's potential to be beautiful, expressive, and impressive. From ancient Egypt to traditional Japan, rural Poland to fashionable Paris, it's a material that holds a special place in art history for its wonderfully versatile and accessible properties. For me it's become a close friend: The perfect partner to build sculptures and communicate ideas with.

I never realized I could become a "Paper Artist" until I discovered I was one. I had early ambitions of becoming an architect or set designer in the theater, never knowing that a job like mine could exist. As an illustration student at university I was constantly bursting out of my sketchbooks, never quite happy to finish a two-dimensional piece. Instead I found myself drawn toward binding books, building puppets, and making stop-motion animations. I turned to paper as a material because it was readily available and gave me quicker results than wood, metal, or clay. It also forced me to simplify shapes and color palettes, which helped my work become more graphic and pictorial.

By the third year of my degree I was making 3D illustrations by building paper dioramas and photographing them, which is essentially what I still do today. I've now been working as a commercial Paper Artist in East London for ten years, collaborating with professional photographers and being commissioned by magazines, brands, and private clients. I'm excited to share with you some of the things I've learned and hope to bring you a little closer to paper yourself! OK, let's get to work.

→ AWL / SHARP POINT

Used mainly for book binding and leather work, the handy awl (pronounced "*all*" as in "*all* you need") provides an excellent sharp point to punch little holes into paper. A good alternative sharp object for this task would be a metal skewer.

→ BONE FOLDER

A bone folder is a dull-edged tool traditionally made from bone, used to score and fold paper and card. Use the tip to score the paper (along with a ruler) and use the body of the tool to crease and flatten the paper once folded. If you don't have one, use a ball point pen that is empty of its nib instead.

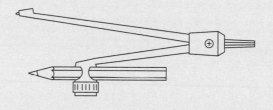

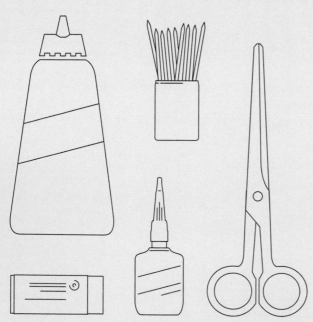

↑ COMPASS

Excellent for drawing circles, big and small. You can also buy compasses with a blade instead of a pencil that can cut entirely perfect circles (once you get the hang of it).

↑ CRAFT KNIFE

The tool I use most! Change the blade with pliers at regular intervals for neater, easier cutting. Instead of a bone folder, I personally use blunt old blades and a craft knife to score with. It breaks and weakens the paper fibres, so it's not widely done, however, it does give sculptures very clean and satisfying fold lines.

↖ CUTTING MAT

Try to find a gridded A1 mat, so you can go large, but for little projects an A3 cutting mat will suffice. Needed for all projects.

← GLUE

Go for a strong, solvent-based gel glue that doesn't stain paper. Strong water-based glue like PVA is too watery and slow to dry. Glue sticks are not strong enough and Super Glue works well for some papers. When gluing tiny areas, I transfer glue onto a toothpick or toothpick before applying, but a small brush works too. For even more precise moments, you can decant some glue into a syringe.

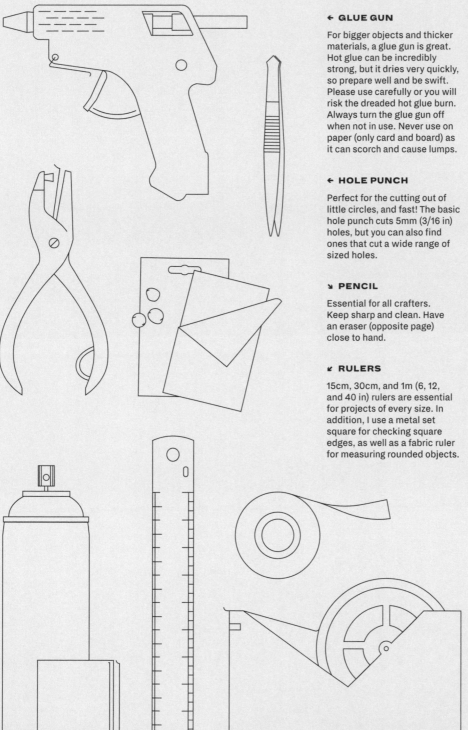

← GLUE GUN

For bigger objects and thicker materials, a glue gun is great. Hot glue can be incredibly strong, but it dries very quickly, so prepare well and be swift. Please use carefully or you will risk the dreaded hot glue burn. Always turn the glue gun off when not in use. Never use on paper (only card and board) as it can scorch and cause lumps.

← HOLE PUNCH

Perfect for the cutting out of little circles, and fast! The basic hole punch cuts 5mm (3/16 in) holes, but you can also find ones that cut a wide range of sized holes.

↘ PENCIL

Essential for all crafters. Keep sharp and clean. Have an eraser (opposite page) close to hand.

↙ RULERS

15cm, 30cm, and 1m (6, 12, and 40 in) rulers are essential for projects of every size. In addition, I use a metal set square for checking square edges, as well as a fabric ruler for measuring rounded objects.

↙ SCISSORS

Ideally choose several pairs in a range of different sizes. Start by finding a standard pair (as shown on the page opposite). Embroidery scissors are perfect for tiny cuts and specialist scissors like wallpaper scissors and pinking shears also come in handy.

↙ SPRAY MOUNT

When sticking two sheets of paper together, permanent spray mount is best. Apply to the surface all over and evenly to avoid any air bubbles. It is best to spray outdoors if it's not too windy, and wear a mask.

← TACK (BLU/STICKY)

Tack is useful when you don't want to permanently stick something down, and want to remove it easily. It's also good for adding depth to layers of card, when rolled into tiny balls, and used instead of glue.

↙ TAPES

Double-sided tape, artist's tape, and some trusty sticky tape are all extremely useful when working with paper. Artist's tape is my favorite—I use it on every project to hold paper parts together while they dry.

↖ TWEEZERS

A must-have tool for the more precise work like fixing tiny details onto a paper sculpture.

OTHER USEFUL MATERIALS!

Needle, thread, and elastic are good to have when hanging and assembling paper sculptures. Wooden skewers come in handy for detailing. I use a lot of acrylic paint for coloring paper.

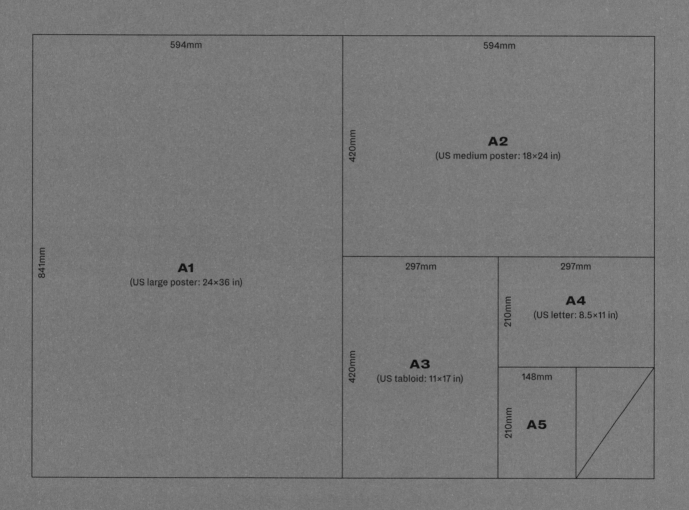

GLOSSARY

→ **COATED PAPER**

Coated paper is paper that has been coated with a compound. This usually gives it added strength, shine, and smoothness, and less absorbency. That's why Super Glue works really well with it. Art paper like cartridge paper is uncoated and will be more matt and absorbent.

→ **FOAMBOARD**

Foamboard or foamcore is a strong and lightweight material that is backed with paper, easily cut with a sharp knife and is often used in picture framing. You can buy it from most art stores in different thicknesses, most commonly 3mm, 5mm, and 10mm (1/8, 3/16, and 1/2 in), and I find it very useful for the interior structure of my paper sculptures. When cutting foamcore, do so slowly and at a 90-degree angle.

→ **MOCK-UPS**

When inventing a new sculpture, it's good to practice on some scrap paper or regular printer paper. It's a chance to properly visualize an idea and experiment. The process also brings up problems that can be resolved with some trial and error before you start the final piece.

→ **MOUNTAIN/VALLEY FOLD**

A mountain fold is when the fold comes toward you and creates the shape of a mountain peak. A valley fold is the opposite and creates the shape of a valley or "V."

→ **MOUNTBOARD**

Mountboard or illustration board is another material commonly used in picture framing, but I use it for structure and creating depth. It's about 2mm (0.08 in) thick with a paper-based core and backing. Due to its thickness and composition, a sharp blade is required to cut it.

→ **PAPER GRAIN**

Most paper is made up of long fibers that align parallel to one another, which means that the paper will be more flexible in one direction than the other. It's more noticeable with thicker paper and card. To test the direction of the grain, take the paper in your hands and gently flex it in one direction, then rotate it 90 degrees and flex it again. You may notice that one way is slightly easier to bend, which means it's "with the grain." It's always best to roll paper in this direction. If you go against the grain, the paper will be reluctant to roll and will easily crease!

→ **PAPER SIZES**

International paper sizes that I refer to can be found in most art shops, and the measurements for these, along with their closest American/imperial equivalents, are shown on the page opposite.

→ **PAPER WEIGHTS**

The gram weight of paper tells us how much it weighs per square meter; the American/imperial weight expresses this in pounds per 500 standard-sized sheets. Usually, the higher the weight, the thicker the paper. Anything 220gsm (58 lbs) and higher is considered card. I tend to use paper and card between 135gsm and 280gsm (36–76 lbs). Check the label on the paper before you buy!

→ **SCORING**

Scoring compresses the paper's fibers so it's easier to fold and so you can mark clearly where you want the fold to be. In most instances you would use a curved edge like a bone folder to do this, but for precise card projects , I prefer using a craft knife with a blunt blade because I find the scores neater, although it will weaken the card. When using a craft knife, consider which side of the card you are scoring. To create a "mountain fold," score the top side of the card and fold. To create a "valley fold," score the reverse and fold.

→ **SKETCHING**

Before cutting, it's sometimes good to sketch the 3D shape you intend to make, so that you can jot down measurements and refer to it while making.

→ **TABS**

Gluing-tabs or just "tabs" are little flaps on the sides of your paper shapes that the glue is spread onto in order to stick to another piece of paper.

→ **TEMPLATES**

Templates are drawings used for the process of cutting out a shape accurately. For 3D objects, the templates in this book are mostly nets of the shape when flat. You'll need a photocopier or scanner and printer to use them. Print them onto 80gsm printer paper at A4 size (21-lb letter). Feel free to scale up; if you do this you'll have to tape the A4/letter print-outs together, lining them up as accurately as you can (unless you can access an A3/tabloid photocopier). You'll find more instructions in the Templates section from page 108. Not all the projects in this book require templates.

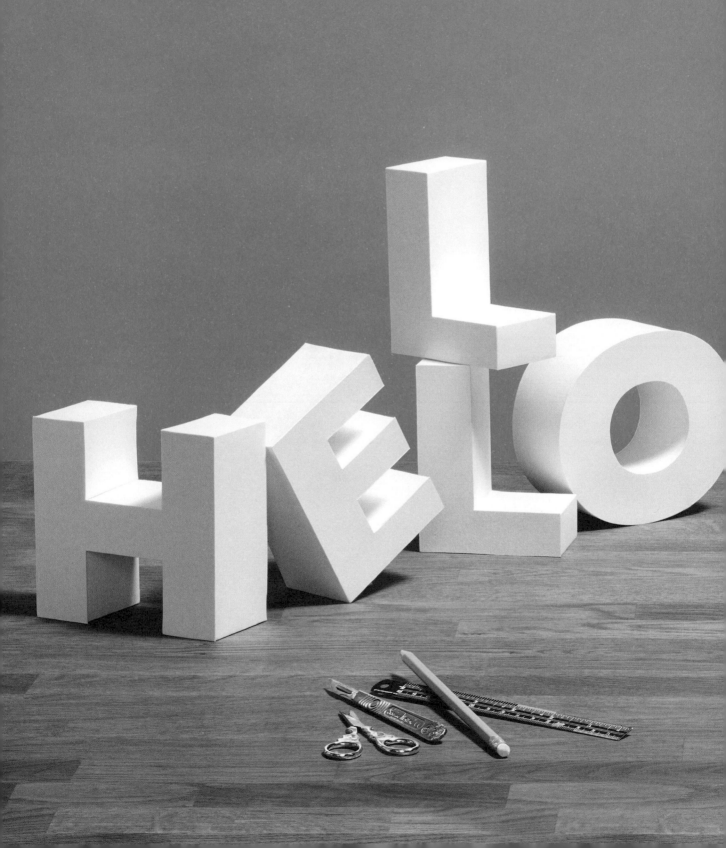

HOW TO SAY

Hello

MAKE **a 3D letter**

USE **tabs**

WORK **with a number of tools**

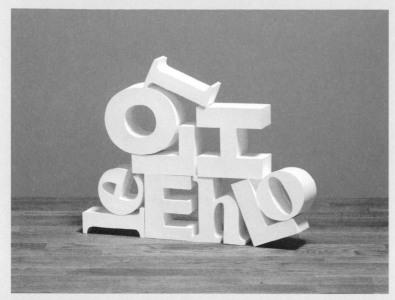

Do your letters and words ever get jumbled up? Mine do!

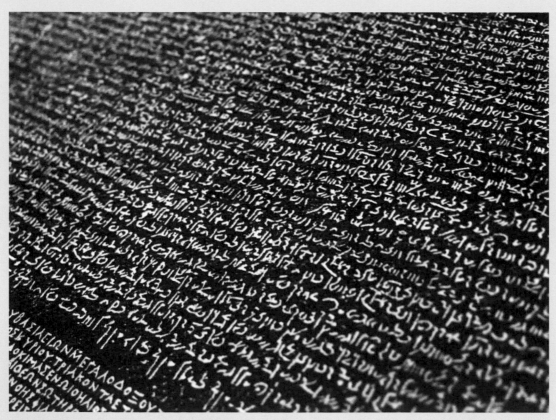

The Rosetta Stone is the oldest physical example of humans using letters to communicate in multiple languages.

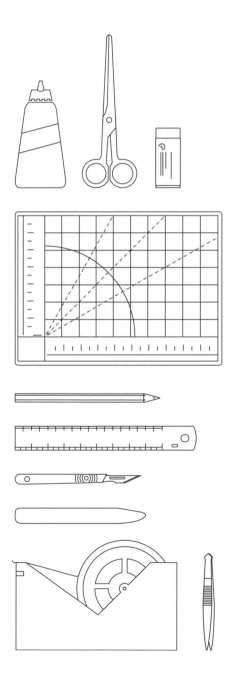

Allow 1 hour per letter

Aloha! Hej! Hello! A friendly introduction is one of the first things we learn how to make, and one of the most useful, so let's start here. I've always found lettering and typography inspiring, a playground of shapes, characters, and styles. I'm no graphic designer, but with enough practice and beautiful reference material, word-building is a fun and achievable way to start sculpting with paper. So, whatever language it is that you speak, let's pick up some paper and work out how to say "hello."

I'll be working through how to build the letter "H," but the same process applies to every letter in every alphabet.

Building 3D shapes requires lots of tabs. Tabs are the little folded flaps that you make when you want to stick one part of a shape to another. I use them frequently, and you'll see them on most templates. In this project, tabs are integral!

When designing a shape, it's very useful to think about the template before cutting. I always make a sketch so that I can refer to it at every stage of the build. For the letter "H" the template will look like one long strip with tabs all the way around. I usually make my tabs 10mm (0.4 in) wide, but if I'm making anything tiny, a 5mm (0.2 in) tab would be better. It's also important to round off the corners of every tab so that they don't get in the way of another tab when the shape is folded. Letters with holes, like A and O, are a bit more complicated because they need two templates. One for the outer side and one for the inner side.

When tabbing round a curved shape use pinking shears to cut lots of small triangles along the score line, so when the paper strip is rolled the triangle tabs can fold neatly at a right angle.

→ CHOOSE YOUR MATERIALS

Use a nice thick card, about 280gsm (72 lb). You'll need gel glue, a 1m-long (1 yard) ruler, a small ruler, scissors, a pencil, eraser, artist's tape, a craft knife, and a bone folder.

→ PREPARE YOUR LETTER

Start by writing a single letter on your computer, choosing the size and font (go for a sans-serif) and print it the same size three times. Alternatively you can draw it by hand and photocopy it twice. They need to be identical. Let's make it 12cm (4.7 in) tall and 5cm (2 in) deep.

→ TAKE DOWN MEASUREMENTS

With a ruler, measure every side of your letter and make a note of it on a printout, next to the corresponding side. On another piece of paper, make a sketch of the template you need to cut out. It will be a long strip, divided into score lines, each section representing a side of your letter. An "H" has 12 sides so there will be 12 sections plus the tabs.

Start by noting down the longest length, and move clockwise around the letter until you have noted down every length, and every score line you need to make. Also draw the tabs onto the sketch so that you don't forget to cut them out!

→ CUT

Take your other two printed letters. Tape them to the card you have selected and cut out each one with a craft knife.

→ MEASURE THE TABS AND SCORE

Use a large sheet of card (A1 ideally) for this next part. Sit it lengthways on your cutting mat, so that it's landscape. Refer to the sketch of the template. First make one long tab along the top length. Measure a height of 1cm (0.4 in) from the top of your card, and mark it at several points along the length with a sharp pencil. Using these marks as a guide, score the length of the card with a long ruler and blunt craft knife or bone folder. Down from this score line, measure 5cm (2 in), marking the card at several points along the length and again score a straight line along these marks. Down from this line, measure 1cm (0.4 in) , mark and draw another straight line all along the length of your card before cutting along the length to release the strip. Put the rest of the card to one side. Make a tab on the far left of your strip, scoring a vertical line 1cm (0.4 in) from the edge. Cut away the corners and rub out any pencil marks.

→ MEASURE EACH SIDE AND SCORE

Refer back to your sketch again to see the measurements for each side of your letter. With a sharp pencil, mark every side measurement at the top and bottom of the strip of card, starting with the longest length and working clockwise around the letter. To make sure your lines are straight, use

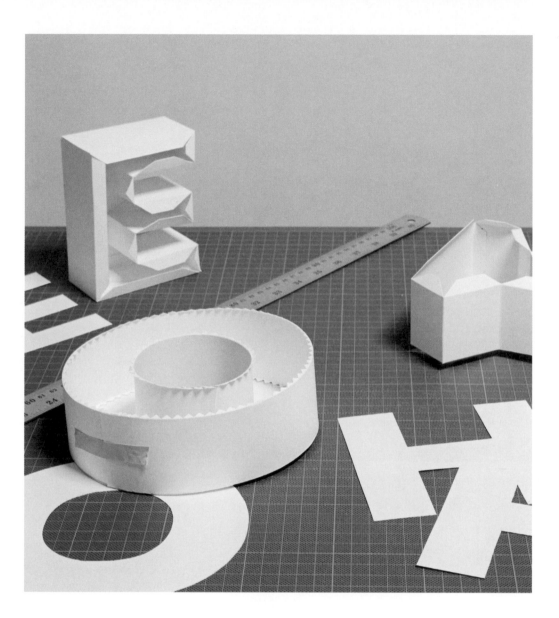

Notice the number of tabs needed for a curved shape like the letter "O."

the grid of your cutting mat to align your ruler or use a set square to check the line is vertical and at a right angle.

Use a small ruler to join up the marks and score vertical lines into the card at each point. When you reach the last marks on the strip, cut. If you find that you don't have enough card for all your measurements you will have to make another strip with tabs and glue the strips together lengthways. If you're using a blunt craft knife to score, think about which way the strip will need to fold around your letter. If it's a mountain fold, score the top of the card, if it's a valley fold score the reverse of the card.

→ MAKE INDIVIDUAL TABS
Do this for each side by cutting triangular notches into each score line. You can refer to Step 10 on the following spread.

→ FOLD
Roughly create the shape of your letter by folding all the sides the correct way. Also fold each tab inward so it is at a right angle to the side. Apply glue to the end tab and glue the ends together—hold in place with some artist's tape.

→ GLUE TOGETHER
Apply glue to all the top tabs and spread evenly. Place the pre-cut letter shape on top, manipulating the sides underneath so they align with the letter. This part is a little bit fiddly, so focus on one section at a time, using artist's tape to hold each section in place while it dries. Stick your other pre-cut letter to the bottom of the shape and hold in place with artist's tape. If there are any edges overhanging, feel free to trim with a sharp artist's knife.

01 Print your letter out three times at the same size.

02 On one of the printouts accurately measure every side of the letter and note down. These measurements will determine the length of the letter's side edge template.

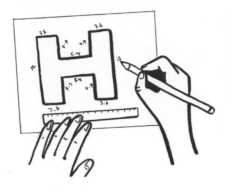

03 Make a rough sketch of the side edge of the letter as a flat template. Decide the width and use your measurements from Step 2 to jot down where each fold should be.

04 Tape your other two letter "H" printouts onto card and cut out so you have two letter shapes. Put to one side for the moment.

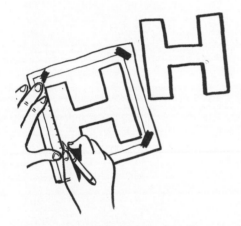

HOW TO MAKE
The Letter "H"

05 Using a sharp pencil, refer to the rough sketch in Step 3 and mark the tabs and the depth of your letter on a big piece of card.

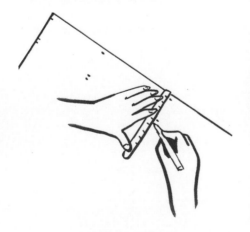

06 Using your marks as guides, score along the length of the card to create two tabs and cut out a long strip.

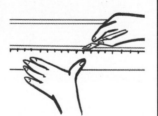

07 Measure and score a 1cm (0.4 in) tab at the end of your strip, and then cut off the corners.

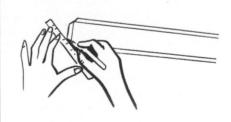

08 Refer to your sketch in Step 3. Measure along the top and bottom of your strip, marking where each fold should be with a sharp pencil.

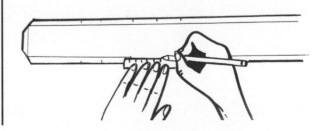

09 Align your ruler to the pencil marks and score vertical lines. Some folds will be mountain folds and others will be valley folds. Refer to page 11.

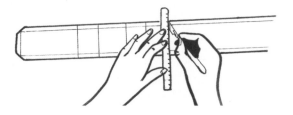

10 Create individual tabs by cutting triangle notches between each score line. Do not cut over the score line.

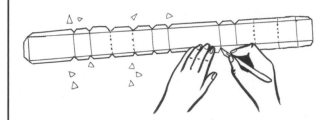

11 Fold all of the scores and start building the outline shape of your letter. Take your time so the folds are crisp and consistent.

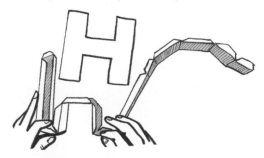

12 Glue the two ends together using the tab you made in Step 7.

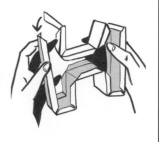

13 The outline shape will not sit perfectly yet. Apply glue to the top tabs and spread evenly.

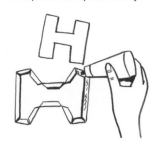

14 With one letter "H" from Step 4, start to manipulate the outline shape so it sticks neatly under the shape of your letter.

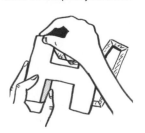

15 Attach it bit by bit and use artist's tape to help you secure it.

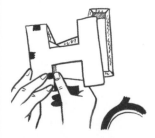

16 Leave the artist's tape in place on the first side while you turn your letter over to work on the other side.

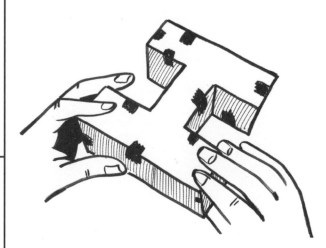

17 Apply glue to all the tabs on the other side. Spread it as evenly as possible.

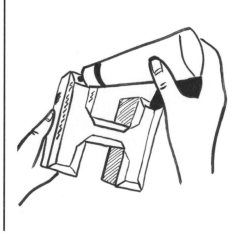

18 Stick your second letter shape to the tabs and use artist's tape to hold it in place while it dries. Trim if necessary.

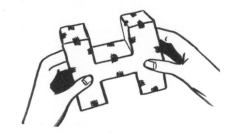

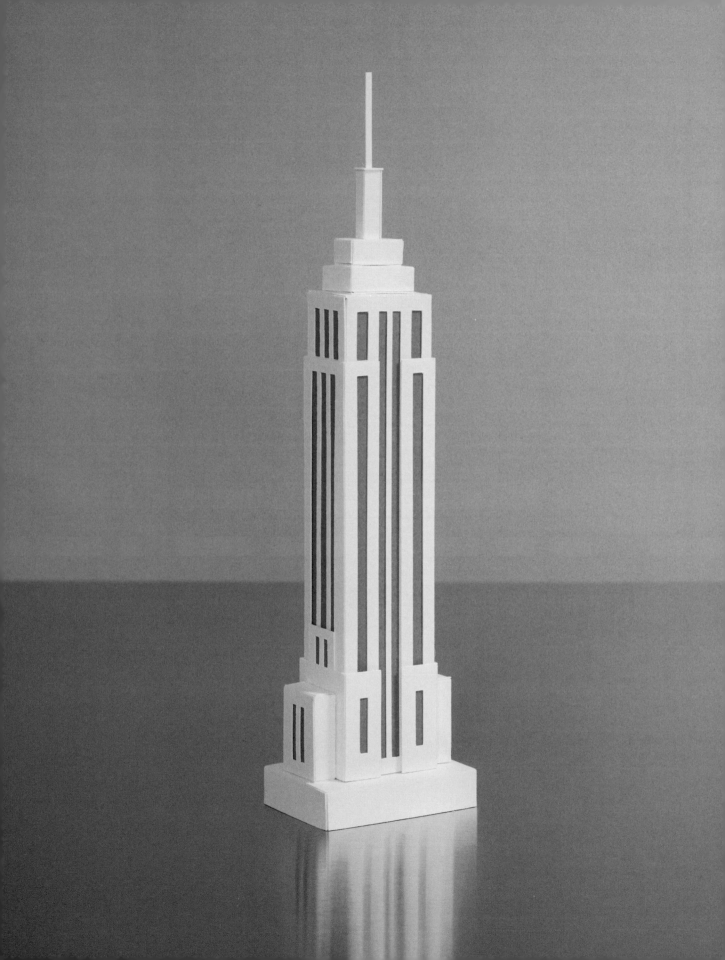

HOW TO SAY Downtown

MAKE a miniature skyscraper

USE a template

WORK with the basic tools

Surely New York looks best
first thing in the morning?

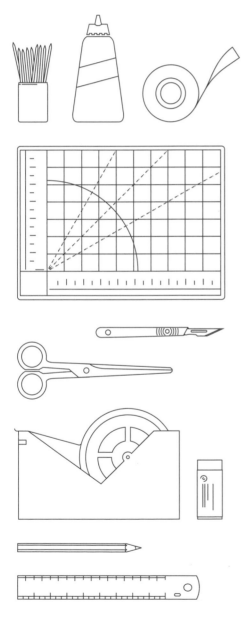

Difficulty

Allow 2 hours

I grew up in the countryside and when I was little, Devon, England felt like one big field, full of lovely plants, bugs, and rivers, but not many buildings. So I started to fill my sketchbooks with imaginary ones. Then I tried making them out of Lego. It wasn't until I visited New York that I really understood how gigantic a skyscraper can be! Completed on the 11th April 1931, the Empire State Building took over a year to build. Don't worry, this mini version should only take a couple of hours!

→ CHOOSE YOUR MATERIALS

You'll need a pale gray or cream card, approximately 220gsm (58 lb) and a blue paper, roughly 135gsm (36 lb), both preferably in big sheets. A craft knife with a sharp and blunt blade, a small ruler, artist's tape, clear sticky tape, and finally some strong gel glue will also be required.

→ PRINT OUT THE TEMPLATES

You will find the templates for this project on pages 110–111. Photocopy and print them out. At the scale provided in this book, these templates will make a model approximately 23cm (9 in) tall, which is quite small so you might want to scale up the printouts.

→ LAY THE TEMPLATES ONTO YOUR GRAY CARD

Place the printouts onto your gray card and fix with artist's tape. When cutting and scoring lots of small parts, my trick is to cover the templates completely in sticky tape. This keeps everything together, and stops it all moving while you cut.

Wooden skewer

2mm (0.08 in) board
covered in paper

5mm (1/5 in) foamcore
covered in paper

10mm (1/2 in) foamcore
covered in paper

*A SLIGHTLY
MORE
COMPLEX
VERSION
OF YOUR
SKYSCRAPER.
THIS ONE
HAS A FEW
MORE STEPS
THAN THE
SKYSCRAPER
PROJECT
I'VE CREATED
FOR YOU!

65cm (25.6 in)

Paper, scored
for neat corners

Artist's tape to hold parts
in place while they dry

Paper

2mm (0.08 in) board

→ SCORE THE DASHED LINES

When I assemble small models, I prefer to use a blade to score paper and card, but it's not everyone's preferred method because will break the fibers of the paper. This will weaken the paper, and there is also the risk of cutting through. However, when it's done correctly it gives really clean lines and you can be more precise. Feel free to use a bone folder if you prefer, but make sure you apply enough pressure so it goes through the printout, onto your card.

→ CUT OUT THE PARTS

Start by cutting out all the windows—the rectangles inside the shapes. Use a sharp blade and take your time. Then cut out all the outer solid lines to release the various parts of the building and discard all the off-cuts.

→ FOLD SCORE LINES AND TABS

Fold all the score lines, including every little tab. If you've cut through a score by mistake, tape it together with sticky tape on the reverse side.

CRAFTY TIP #02

A quicker way to make a small box is to cut the shape out of foamboard and cover the top and sides in paper.

→ FILL THE WINDOWS

Stick blue paper behind the windows to fill them in. To do this you will need to cut out little squares and rectangles to fit inside. Measure the space around the windows on each part and cut a piece of blue paper to match. Make sure you don't make them too big, because the tabs need to fold at a right angle, and the paper could stop them doing this.

Apply a small amount of glue to the areas around the windows on the reverse of each of the building parts and stick your blue card pieces on.

If you notice that an area hasn't stuck completely, you can apply a little bit of glue to a scrap piece of card and slide it in from the front, through the window and onto the area you need to cover.

→ GLUE THE PARTS TOGETHER

Locate the seven shapes you've cut out that have tabs; parts labeled A, F, G, H, I, J, & K. These need to be made into 3D boxes. Apply glue to the tabs (with a toothpick) and begin creating the boxes. Use artist's tape to hold in place while they dry.

→ GLUE THE SIDES ON

Apply glue to the back of parts B and C, which should be folded and have blue windows already. Stick these to the sides without long windows of A, so that the bottoms match and the folds wrap around to the front of the building.

→ GLUE ON THE SMALL SIDE PARTS

Repeat with parts D and E. Glue them to B and C respectively, making sure they're flush to the base and also wrap around the front of the building. Glue the little boxes, F and G, on top of sides D and E, so they are also flush to the base.

→ GLUE THE TOP AND PINNACLE TOGETHER

Stick the small boxes, I, J, and K onto the top of A, biggest to smallest, K being the smallest sitting upright. Slot the little strip L (the pinnacle) inside a notch cut out of the tiny square. This needs to stick on the top of K. Because it's so small, I haven't given tabs for the square to stick to. Just place the glue on the edge of the card.

→ FINALLY...

Stick the whole thing onto the remaining box, H and remove all the artist's tape, carefully without ripping the card. Look ahead to pages 30–31 for more architectural inspiration.

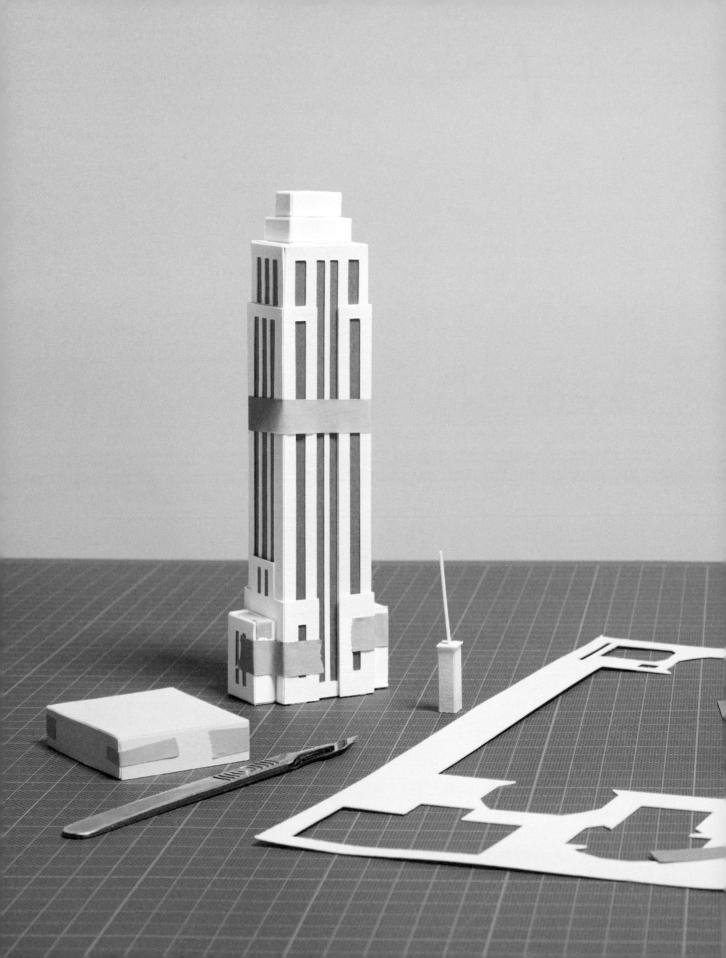

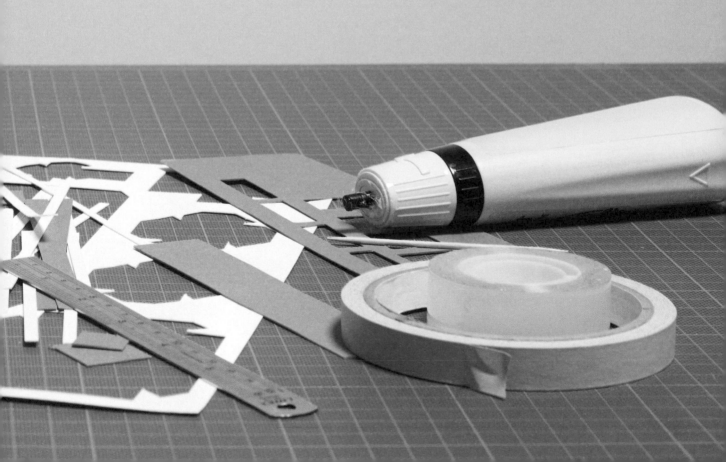

01 Photocopy the templates and lay out onto your card and tape down. Cover in clear sticky tape.

02 Score all the dashed lines and cut all the solid lines.

03 You should be left with all these parts (templates labeled A to L). Fold all the score lines.

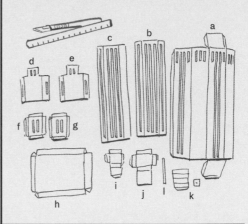

HOW TO MAKE

The Skyscraper

04 Measure the space around the cut-out windows on each part that has windows.

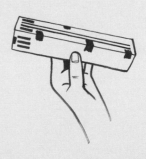

05 Cut rectangles to fit inside in a different color. In this case we have chosen blue card.

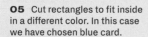
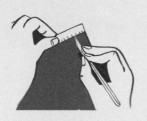

06 Glue these blue rectangles to the reverse of each relevant part, allowing space for the tabs to be folded at right angles.

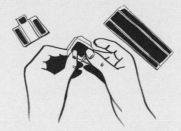

07 Use a piece of card with glue on it to go over any areas of the windows that haven't stuck properly.

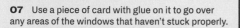
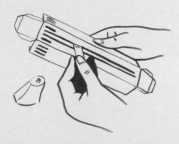

08 Locate the shapes that have tabs (A, F, G, H, I, J, & K) and glue them together into 3D boxes. Any small windows should be at the top of each shape.

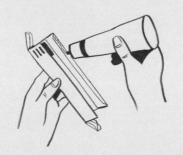

09 Use artist's tape to hold parts in place while they dry.

10 Locate the side pieces labeled B and C. Apply glue to the reverse, spreading evenly.

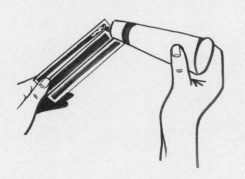

11 Stick both to the sides of A, flush to the bottom and folded around to the front and back.

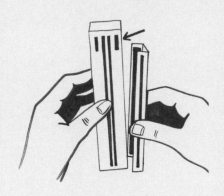

12 Repeat with the smaller side pieces labeled D and E.

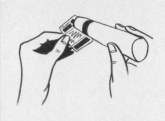

**TEMPLATES
pages 110–111**

13 Stick them flush to the bottom of pieces B and C.

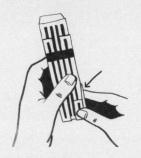

14 Apply glue to the tabs of the small boxes that have windows (F and G)…

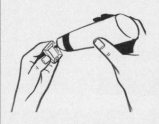

15 …and stick onto D and E flush to the bottom, using artist's tape to hold in place.

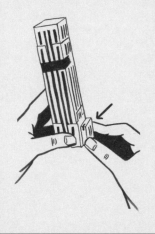

16 Add the little boxes, I and J to the top, first the bigger one followed by the smaller one.

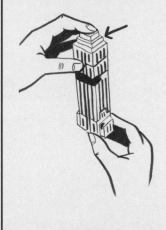

17 Slot the small strip of card, L, into a slit cut in the square that forms part of template K.

18 Stick it to the top of the long thin box (K) with a bit of glue applied to the card edge.

20 Attach the whole structure to the bottom box labeled H and lastly, remove the artist's tape very carefully when everything is dry.

19 Glue the thin box to the top of the model.

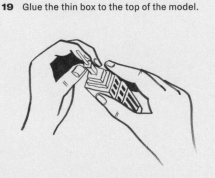

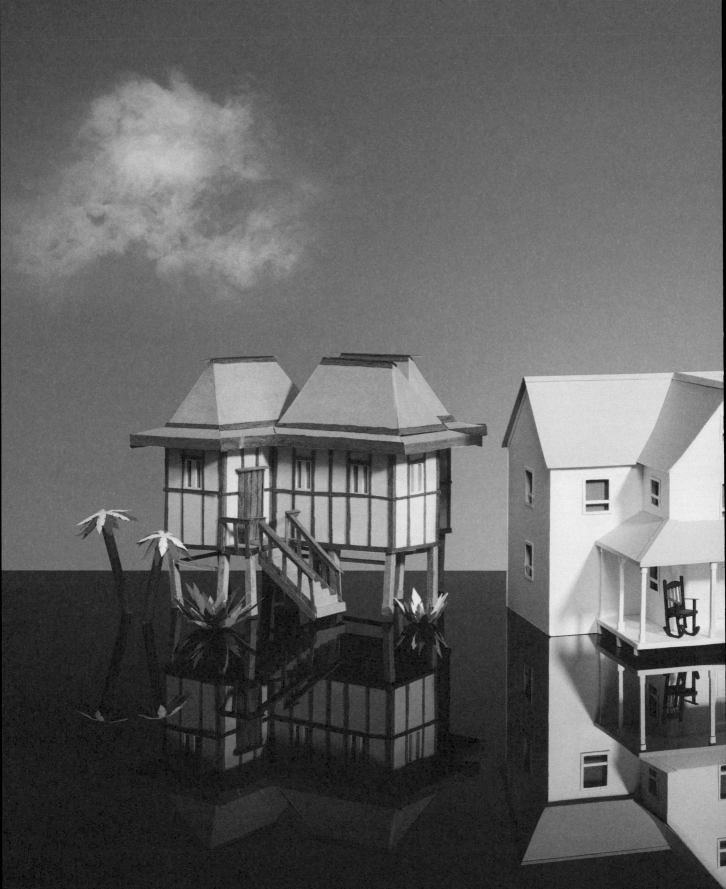

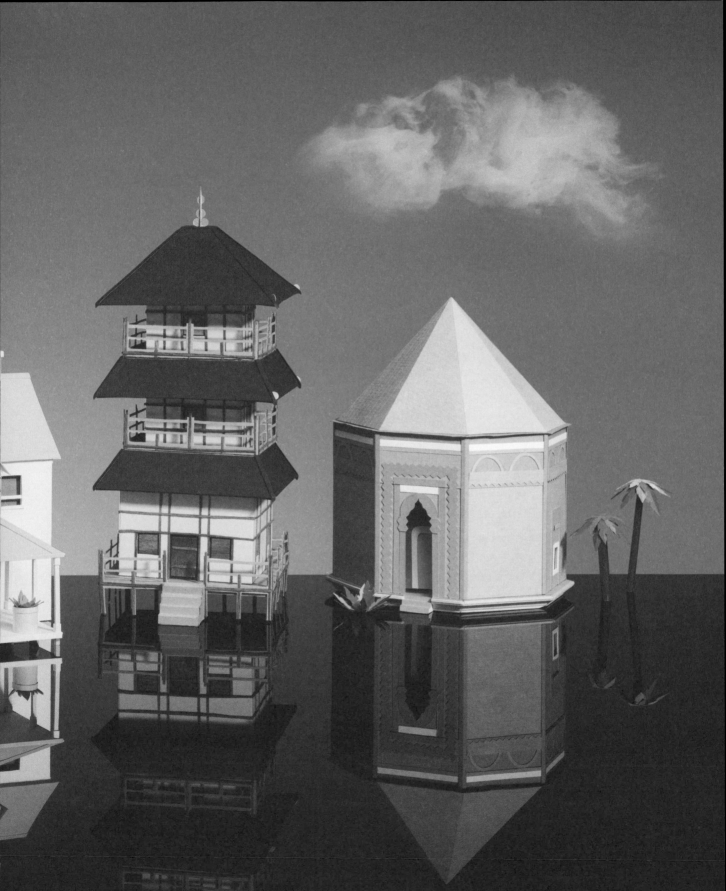

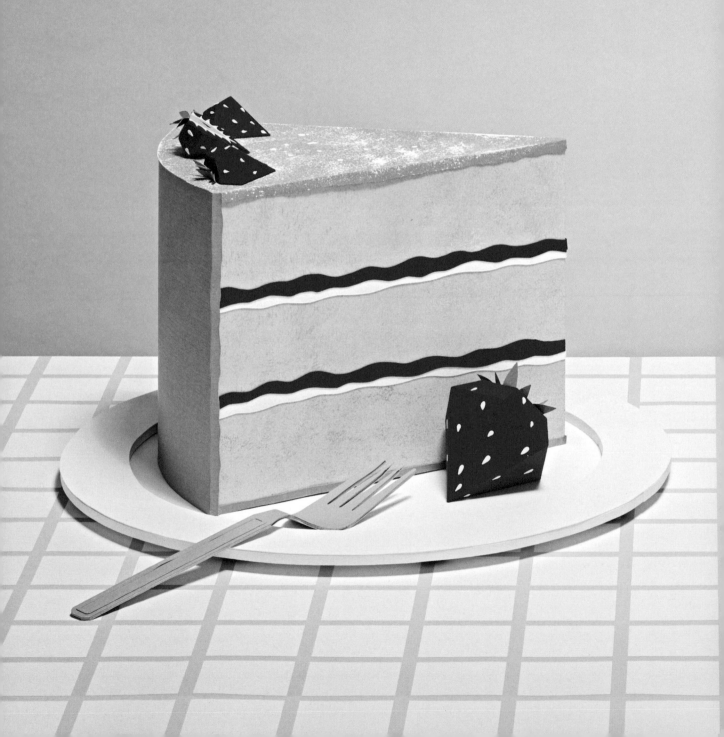

Yum

MAKE a slice of cake, and more

USE thicker materials

WORK with or without a template

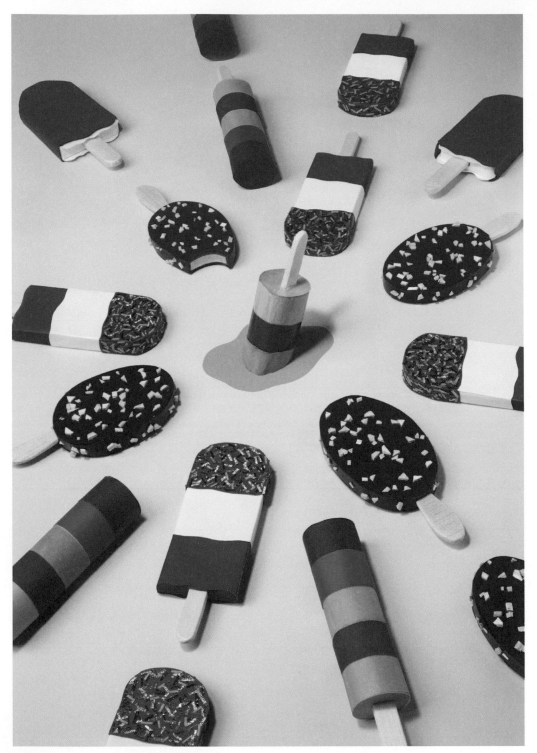

A collection of colourful paper popsicles ready for display (not for eating I'm afraid!)

Difficulty

Allow 5 hours

Food is one of the most satisfying and fun things to replicate in paper, even though it's not edible. It's all about suggesting the textures and consistency of the food you're making. If I'm working on a lettuce I'll scrunch the paper right up before I cut it, creating lots of crinkles. If I'm making a popsicle I'll bring out my glossiest, stickiest-looking paper to make it look sweet and delicious. I've always been a better maker than baker, so let's swap our measuring jugs for rulers and get this classic Victoria sponge cake underway.

→ **CHOOSE YOUR INGREDIENTS**

Use a large sheet of card about 220gsm (58 lb). Any thinner and the paper might wrinkle and pucker when glued. For a Victoria sponge cake you'll need two shades of beige, one for the sponge and another for the top, side and bottom crust. You'll also need a color for your filling—red and cream in this case.

The slice of the cake in this project should be a big one, 25cm (9.8 in) wide and we want it be strong so we'll also be working with 5mm (3/16 in) foamcore, a material I use for anything oversized, to give strength and structure. You can buy A1 (poster-sized) foamcore sheets from most art stores. It comes in 3mm, 5mm, and 10mm (1/8, 3/16, and 1/2 in). You'll also need artist's tape, scissors, a ruler, a fabric ruler, a pencil, a compass, a set square, an eraser, craft knife, a glue gun, gel glue, a bone folder, some acrylic paint, a brush to mix with, and an old kitchen sponge.

→ **GIVE YOUR CARD TEXTURE**

Time for something a bit different. Take your acrylic paint and mix a color that's slightly darker than the beige card you'll be using for the sponge and apply lightly with a kitchen sponge giving the card a speckled pattern. It's a good idea to have a little practice on a scrap piece first. To suggest icing sugar, lightly sponge white acrylic to the piece of card that you will use for the top. Put this to one side to dry.

01 Tape the template to red card and score the dotted lines with a blunt craft knife.

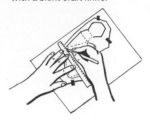

02 Cut the outside lines to release the shape and fold the scored lines to make it 3D.

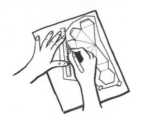

03 Glue the sides all together.

04 Glue the lid piece closed.

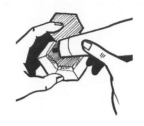

05 Using the template cut out the leaves from green paper.

HOW TO MAKE
The Strawberries

TEMPLATES
page 112

06 Glue them to the top of the strawberry and curl.

07 Cut out a little paper stalk with scissors or your knife. Glue it onto the top leaf so that it stands upright.

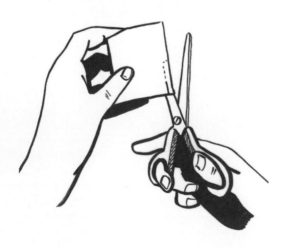

08 Cut out a number of pips from a pale yellow paper.

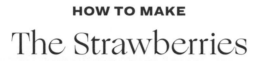

09 Glue the pips onto the strawberry using your tweezers.

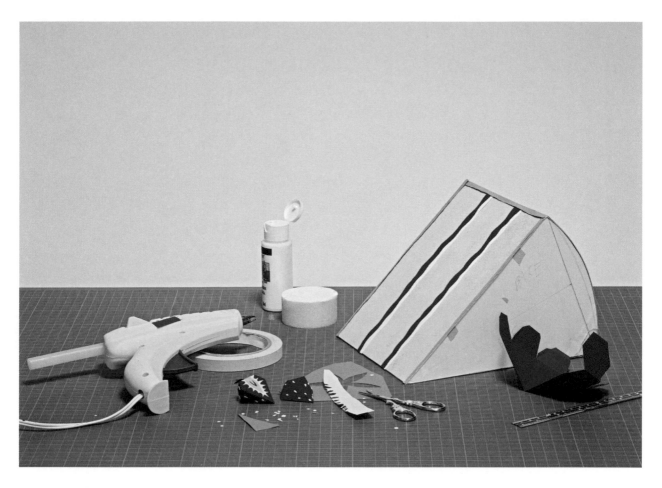

Foamcore is perfect to support the structure of larger paper models.

→ PLAN YOUR DESIGN

Make a sketch of the cake shape before you start building, deciding the width, depth, and height of the structure. Make the sides 5mm (3/16 in) shorter in length than the two longer sides of your top triangle. See Step 3 on page 38.

→ PREPARE THE FOAMCORE STRUCTURE

Transfer your measurements to your foamcore, using a pencil, ruler, set square, and a compass for the round edge. You should have five parts; top, bottom, and three sides. Use a fabric ruler to measure the curved side, or over-estimate with a metal ruler and trim later. With a craft knife, cut out all your foamcore parts. The curved side will need to bend, so score from top to bottom every 5mm (3/16 in) and fold into a curve.

If you accidentally cut all the way through, reinforce with some sticky tape on the inside. Check whether it matches the curved edge of your top piece, and trim if necessary.

01 Paint your card with paint and a sponge to give it texture. Use varnish for added shine.

02 Draw out all the foamcore pieces that will make up the structure of your cake.

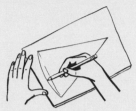

03 The top and bottom triangles should be 5mm (0.2 in) longer than the straight side pieces.

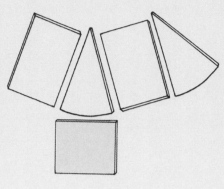

04 Cut out all the parts. The curved side needs to be scored from top to bottom using a ruler and a craft knife so that it will bend effectively.

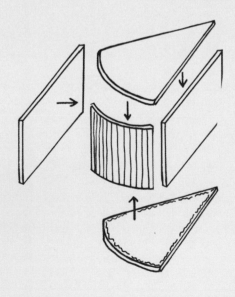

HOW TO MAKE
The Cake

05 The next step is to glue together all the foamcore pieces to form your slice of cake. Make sure you...

06 ...glue little foamcore right-angled triangles inside your structure to strengthen and straighten.

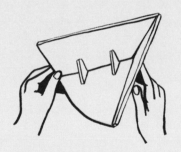

07 Use a glue gun, taking care not to add too much glue.

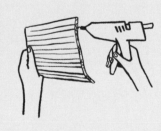

08 Use artist's tape to help keep the sides together while they dry.

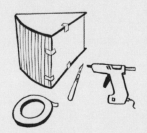

09 Measure the sides and transfer the measurements to your painted card.

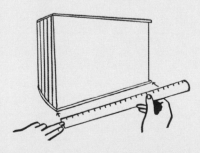

10 Cut the sides of the sponge slice from one piece of painted card and make a sharp scored line down the middle.

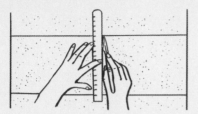

11 Spread the glue evenly over the card and stick to the foamcore structure.

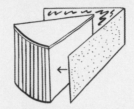

12 Cut the flavored filling from the red and cream card in wavy lines. You will need four in each color.

13 Stick the filling layers together and then onto the sides of your cake.

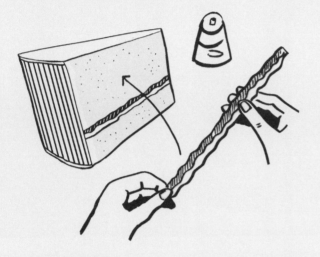

14 Accurately trace the shape of your slice onto the darker beige card.

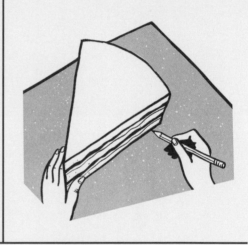

15 With a craft knife or bone folder, score the long lines and cut the curve.

16 Cut along the long straight edges to create a wobbly line—release the shape and fold the scored lines.

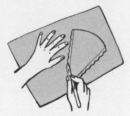

17 Rub out any pencil marks and stick the top on, gluing the reverse all over.

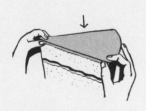

18 Do the same for the top and the curved outer edge of the cake and stick on also.

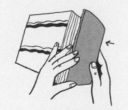

19 Accessorize your slice of cake with strawberries or a sparkler!

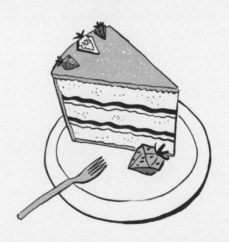

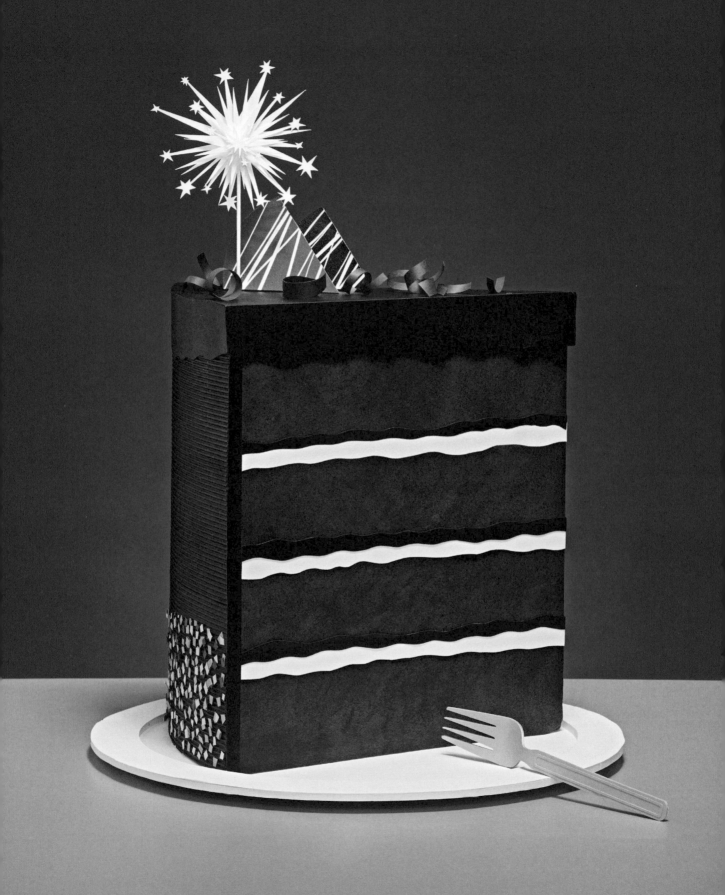

Paint your paper before you start and you can try spraying it with a varnish for a delicious, glossy finish!

→ **GLUE TOGETHER FOAMCORE STRUCTURE**

Now glue all the parts together with hot glue. Start by sticking the side pieces along the edges of your base piece, using little right-angle triangles made out of foamcore as supports (see page 38). Artist's tape is always useful to keep your structure together while the glue dries.

→ **COVER THE SIDES IN CARD**

Measure your foamcore structure with a ruler and note down the measurements. The foamcore adds 5mm (3/16 in) to the top and bottom so the measurements will not be the same as your earlier sketch. Take your painted card from earlier and transfer the measurements with a pencil and ruler. Be sure to make the two "cut" sides of the slice of cake from one single piece of card, with a score along the middle so it can fold and give a clean, sharp edge to create your "slice." Apply glue to the reverse side, covering the whole surface, and stick to the foamcore, taping it in place while it dries.

→ **MAKE THE FILLING**

For two layers of filling, cut out eight long, wobbly strips of paper, four in red and four in white. Trim them so they are the same length as your cake before sticking them onto the sides in pairs.

→ **COVER THE TOP**

With a pencil, trace the shape of your cake onto the card you prepared for the top crust. To give the crust some depth, add a fold to each straight side. To do this, carefully score the long straight lines you have drawn with a craft knife/bone folder and ruler. Rub out the pencil marks. On the outer side of these score lines, cut a wavy line parallel to the score lines with your craft knife about 5mm (3/16 in) distance away. Cut the curve, releasing the shape, before folding the score line. Evenly cover the reverse side of this piece of card with glue and stick to the top of your structure, folding the wavy edges over and gluing down onto the sides. Repeat this process to create the base of the cake crust.

→ **COVER THE OUTER EDGE**

Do the same with your curved outer side piece.

→ **STRAWBERRIES**

Use the instructions on page 36. The template can be found on page 112 and makes a strawberry about 13cm (5.12 in) tall.

→ **SPARKLER**

Photocopy page 113, and use as a guide to cut out the sparkler shapes. Stick the shapes together with balls of tack, from smallest to biggest. Paint a wooden skewer gray and stick in between the layers. Punch a small hole in the top of your cake with an awl and insert your sparkler!

Fresh Patterns

Sometimes when I'm making things, I make a patterned material for myself to build with, almost like wrapping paper.

Dots, spots, stripes, zigzags: create your own pattern by cutting it out of paper, designing one on a computer, or finding a patterned paper that you love!

Now use this to build with, giving your paper sculpture an extra bit of magic. There's a template for an unopened banana on page 114 and a strawberry on page 112.

Food isn't meant to be boring, so let's go bananas!

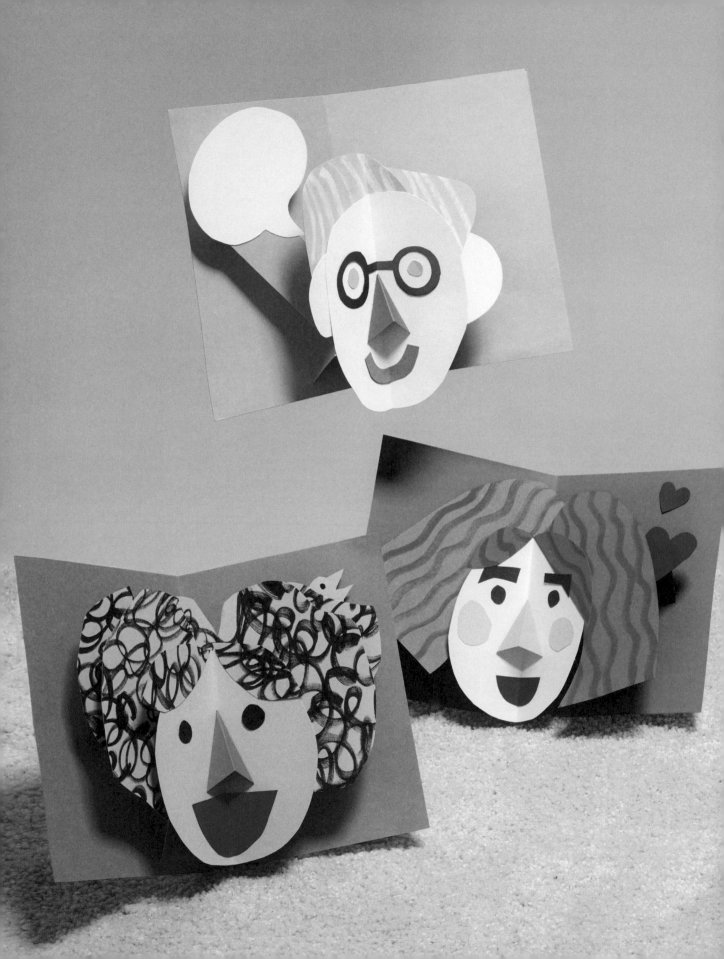

Surprise!

MAKE a pop–up portrait

USE pop–up mechanisms

WORK with layers

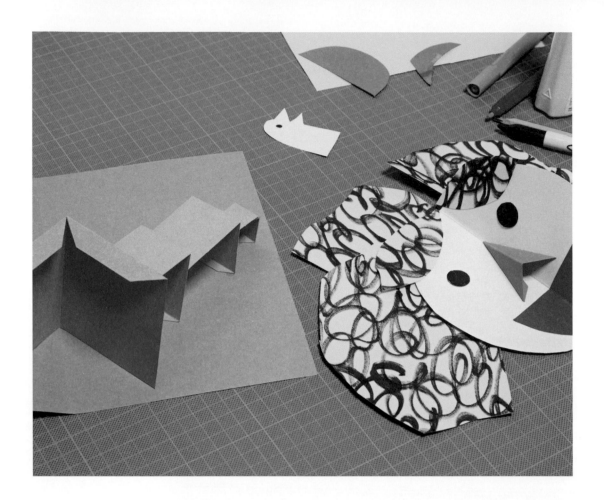

The fold in the
nose must match
up perfectly to the
spine of the face
so they close and
open together.

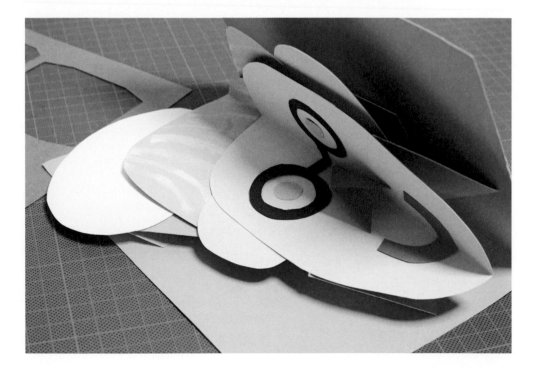

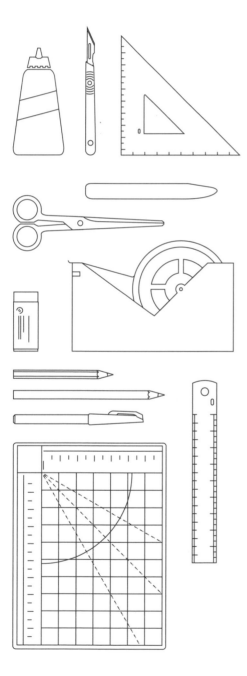

Difficulty

✂ ✂ ✂ ✂ ✂

Allow 1 hour

Everybody loves a nice surprise and it's fun watching someone open up something special you've made for them. Shop-bought cards can be uninspiring sometimes, but a homemade card never disappoints. There are lots of reasons to give someone a nice card, but my favorites are the ones they aren't expecting to celebrate—like "Nice haircut!" or "Thanks for being a great pal!" or "I got you a ticket to that show!" The reason for the surprise is the first thing you have to decide upon, then it's all about bringing it to life using color, card, and lots of creativity.

→ CHOOSE MATERIALS

You'll need a selection of A4/letter colored card, 220gsm (58 lb), any coloring pens or pencils you want to work with, as well as a craft knife, gel glue, a ruler, scissors, an eraser, and a pencil. Every fold made must be scored, creased, and flattened with a bone folder to give it maximum strength and flexibility so you'll need one of these too.

→ PREPARE

On a piece of paper make a sketch of your design. When I make a fun paper portrait of a friend I choose three of their unique characteristics and exaggerate them.

My friend Nadia is full of energy, has a big smile, and has wonderful black, curly hair going all over the place! Her hair has inspired me to make lots of curly marks on my card with a felt-tip pen. Pick out the colored card for your base and face. Fold both pieces in half, lengthways so they both have a central spine.

Use a piece of card or paper approximately 220gsm (58 lb).

Score and crease folds sufficiently.

Check lines are parallel.

Evenly apply glue to the tabs.

Color and decorate while pieces are flat.

→ MAKE THE FACE

Out of the card you have selected for your face cut a circle no bigger than 15cm (6 in) diameter. A quick way to do this is to fold your card in half and use scissors to cut a semicircle through both sides so that is forms a circle when open.

Now make the features for your face—eyes, mouth, ears, and nose. To make a 3D nose, use a small piece of folded card and make diagonal tabs to create the shape of a triangle. Stick onto your face, lining the folds up so that when the card is closed the nose lies flat. The hair will be on a separate layer so prepare some pieces for it and we'll attach them later.

→ MAKE THE POP-UP MECHANISM

Using the same colored card as your base, cut a strip 8cm (3.1 in) tall and 16cm (6.3 in) wide. Fold in half (so the fold is along the shorter side) and score 4 x 1cm tabs along the top and bottom with a ruler and a bone folder (see step 6 on page 52). Cut the corners of the tabs. Fold the tabs so they all face away from you.

→ PREPARE YOUR BASE CARD

Return to your base piece of card and mark where the first tab will be glued. With a pencil, draw a faint, straight line a third of the way up the left-hand page, at a 45-degree angle down from the center fold line toward the left-hand corner. You can use a 45-degree set square or protractor if you want to be accurate.

→ ATTACHING THE POP-UP MECHANISM

Apply glue evenly to the bottom left tab of your pop-up mechanism. Carefully stick the tab along the pencil line. The central fold line of the pop-up mechanism must be touching the center fold line of your base card. Hold down for a moment while it dries. Now flatten the mechanism so it sits on the left-hand side of the page. Apply glue to the bottom right tab—make sure it's folding away from you! Carefully close the base card and the tab should find its natural sticking position on the right-hand page. Press down hard and wait a minute before opening again. When you open the base again, the mechanism should now pop-up.

→ STICK THE FACE ON

Apply glue to the top tabs and stick on your face, making sure that the fold lines of the base card and the face are aligned and parallel. When you close the base card the face must fit inside.

→ ADD MORE DEPTH AND DETAIL

Cut two strips of card 5cm (2 in) tall and 12cm (4.7 in) wide. Fold each one in half and score 1cm (0.4 in) tabs into each

An easy way to glue together a simple V-fold pop-up is shown here.

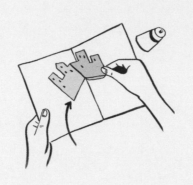

A Apply glue to one tab and stick to the base, making sure both spines meet as above.

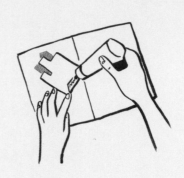

B Fold the pop-up piece flat and apply glue to the other tab, folded away from you.

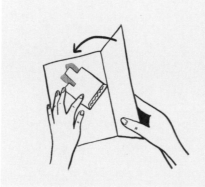

C Close the base card and the tab should find its natural sticking position.

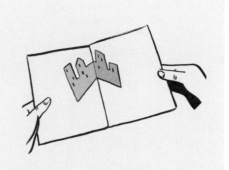

D Press it down while it dries. Open the base and the piece will pop up!

end (see step 17 on page 53), cutting the corners off as before. Prepare to stick them to the back of the central mechanism. To do this, take your first folded strip. Evenly apply glue to one tab, and stick it to the back of the central mechanism so that it is parallel to the top edge, about 3cm (1.2 in) down from it. Wait for it to dry and now fold the strip so it closes (rather than opens out).

The tab should be flat and not folded inward. Apply glue to the top face of this tab, spreading evenly and carefully. Close the base card and the tab will find its natural sticking position. Press down to secure and let it dry. The piece will pop up when you open the base. Repeat with the second strip on the other side. You can add as many of these layers as you wish, in different sizes. Just make sure that they fit inside the base when the base is closed.

Stick your details on top of these layered parts, making sure they do not cross the spine (or the base card might not close cleanly). Finally, add a message to the front and give your card to someone special!

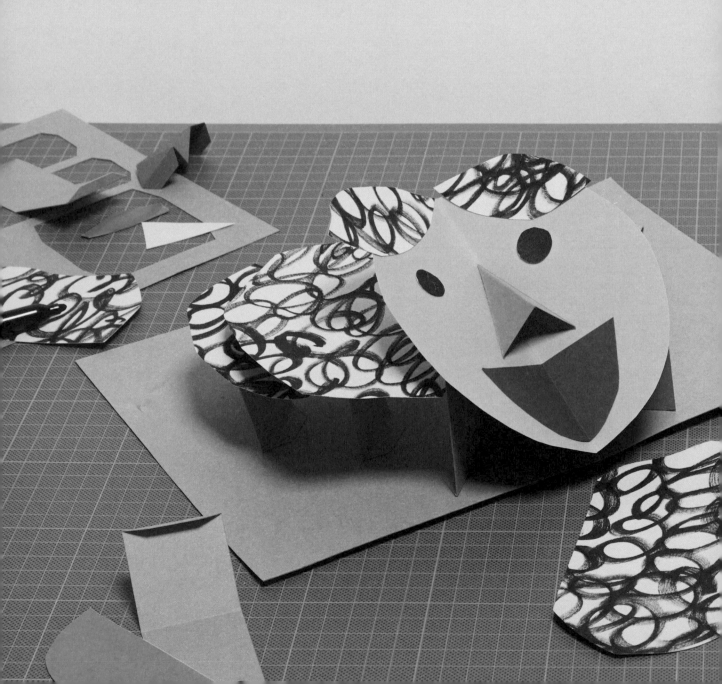

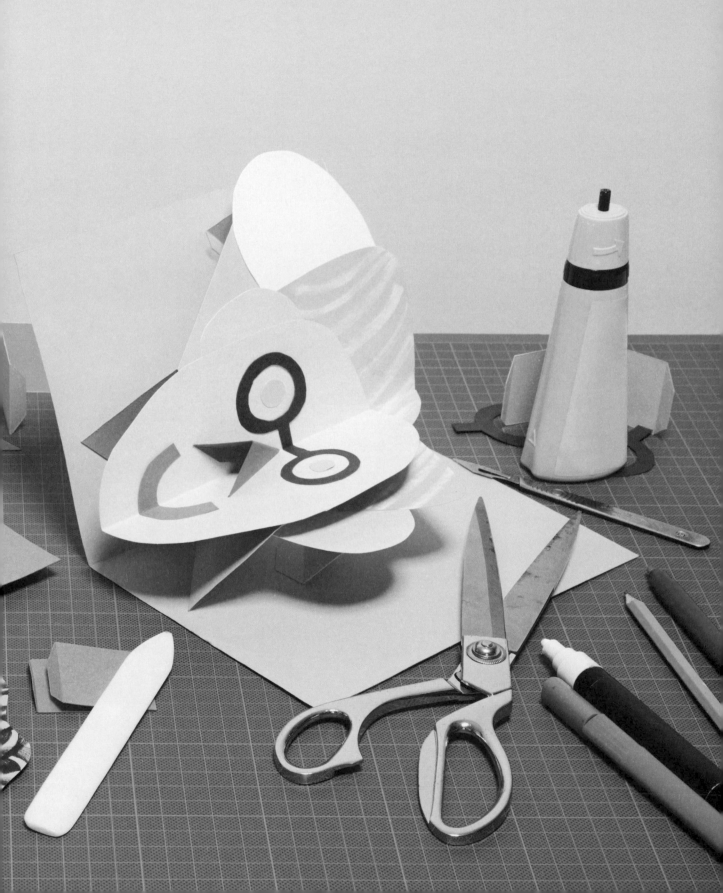

01 Sketch your card design on a piece of paper.

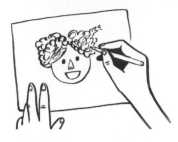

02 Choose an A4 colored card for the base card and fold in half.

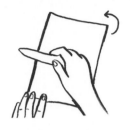

03 Choose a colored card for the face, fold in half, and cut into a circle no more than 15cm (6 in) in diameter.

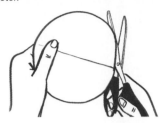

04 Make features like hair but keep to one side. To add a 3D nose to the face, fold a piece of card and make diagonal tabs. Line up the fold with the spine of the face so it will sit flat when closed.

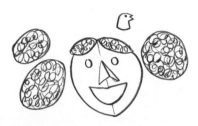

HOW TO MAKE
The Pop-up

05 Start making the pop-up mechanism. Use the same color as your base, and measure and cut a strip of card 8cm (3.1 in) tall and 16cm (6.3 in) wide.

06 Fold the strip in half and measure and score 1cm (0.4 in) tabs to the top and bottom. Remember to cut the corners of the tabs.

07 On the left page of your base card, draw a faint line, about a third of the way up the page, and at a 45-degree angle from the central fold.

08 Apply glue to the bottom left tab of your pop-up mechanism and stick it along the diagonal line, touching the central spine fold, with the tab facing away from you.

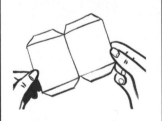

09 Fold the pop-up mechanism flat and apply glue to the bottom right tab.

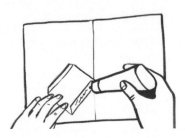

10 Carefully close the base so that this tab will find its natural sticking position.

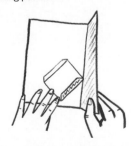

11 Press and hold the base closed as it dries.

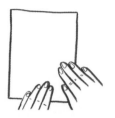

12 When you open the base, the mechanism should pop up.

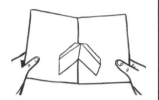

13 The mechanism and top tabs should fold away from the bottom of the base.

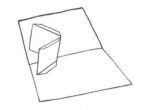

14 Apply glue to the top tabs spreading evenly.

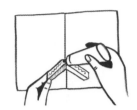

15 Stick your face to the tabs, lining the spine to the center so that it folds flat when the base card is closed.

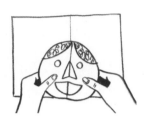

16 Cut two strips of card in the same color as your base, 5cm (2 in) tall and 12cm (4.7 in) wide.

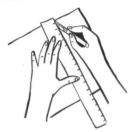

17 Score and fold them in half and add tabs to either end. Cut the corners off the tabs.

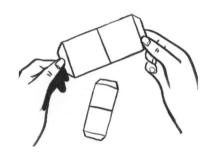

18 Fold each strip into a right angle and stick behind the central mechanism, one on each side. Every fold MUST be parallel to the central mechanism.

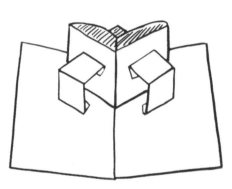

19 For more layers, add more folded strips in descending sizes. Stick the details of your card to the top of these parts.

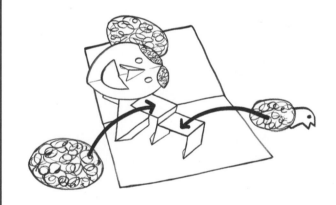

20 Make sure your layers to do not cross the spine and trim so they fit neatly inside the base when closed.

21 Add a message to the front of the card and voila! A special card for a special person!

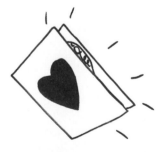

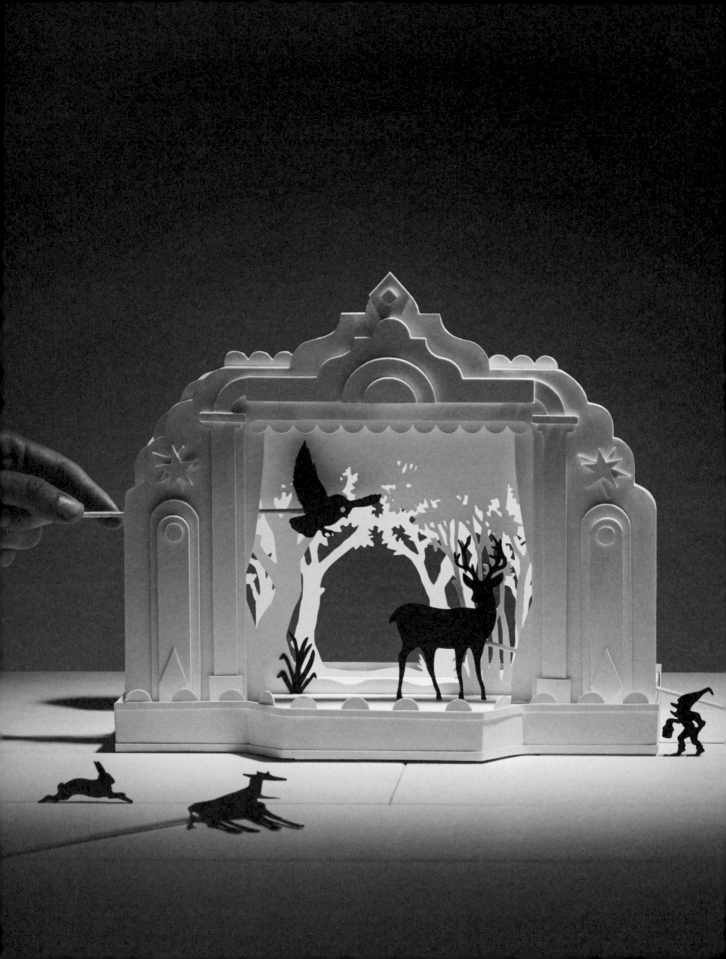

HOW TO SAY # Bravo!

MAKE a toy theater

USE layering to create depth

WORK in black and white

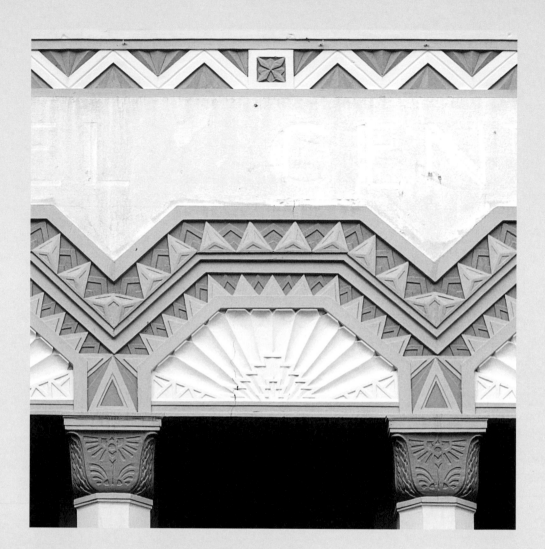

I love taking inspiration from the buildings I see like these beautiful Art Deco columns.

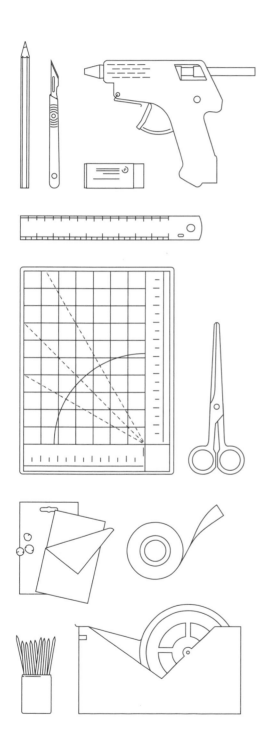

Difficulty

✂ ✂ ✂ ✂ ✂

Allow 1 day

A little toy theater was one of the first things I can remember ever making out of paper. My Mom bought me a kit and it kept me quiet for hours. I loved putting together the layers, cutting out puppets, and making up stories to put on stage for my imaginary audience. Building scenery on a miniature scale is great fun, playing with the illusion of depth by using multiple layers. I've got a particular soft spot for Art Deco theaters, so I thought we could make one in the classic style, grand and dramatic, and in black and white!

→ CHOOSE YOUR MATERIALS
You will need white and black card, about 300gsm (82 lbs), and a large sheet of 5mm (3/16 in) foamcore. Have your ruler, gel glue, glue gun, pencil, tape, sticky·tack, and wooden skewers at the ready. This project requires a lot of intricate cutting, so a sharp craft knife is vital. Change your blade about three times throughout the make. When cutting foamcore, do so slowly and at a 90-degree angle. You will find that it becomes a lot trickier to glue the pieces together if they are not cut square.

→ PREPARE YOUR TEMPLATES
Find the templates starting on page 120 and follow the instructions on page 60. Some templates will need to be photocopied more than once.

→ MAKE THE BASE OF THE STAGE
Cut the shapes from Template 1 out of foamcore. Glue the corresponding rectangles to the sides of the larger shape to make it 3D. Firstly with regular glue and then with hot glue to secure. Use artist's tape to help keep the pieces tightly in place while they dry.

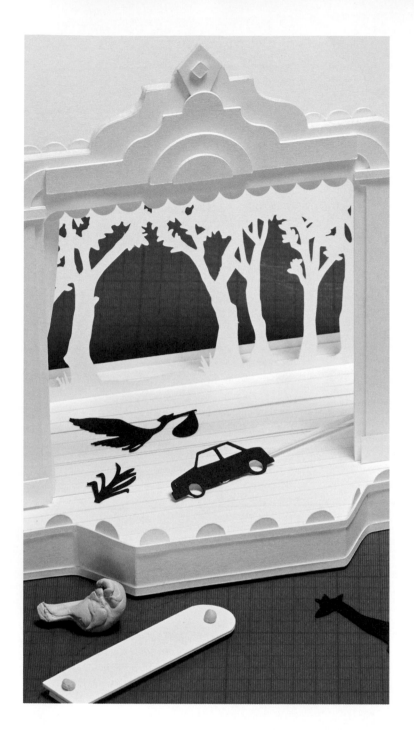

Use tack instead of glue to give your 2D details more depth.

→ MAKE THE TOP OF THE STAGE

Now turn to Template 2. Tape to foamcore and cut out the shapes. Glue the largest piece to the top of your base, so it matches up to the front and the sides are flush. The foamcore rectangles need to sit together with tiny spaces between them, so later you can slot your card scenery into the gaps. To make the spaces the correct size, cut some rough strips of card and sit them between your foamcore rectangles as you glue them down. The thinnest rectangle goes at the back. Once dry, remove these strips of spacer card.

→ LAY THE FLOOR BOARDS

Flip your stage over and place onto some white card. Draw around this to create the outline of the stage. Put your base to one side. The outline shape you are left with on the white card will be used to create the floorboards. The floorboards need to be narrow and cut parallel to the slots in your stage. To help you do this, mark 1cm (0.4 in) increments along the sides, align your ruler to them and cut. Repeat until you have multiple strips to fill your stage. Cut all the way around the shape to release the floorboards before gluing to the top of the stage. I like leaving a minuscule space between each one to give a bit of shadow and resemble real floorboards. Do not cover the two holes or the slots, so trim the strips where necessary. You might also want to turn the stage over and trim any strips that are overhanging the edges.

→ MEASURE AND CUT THE SIDES

Using the circles on Template 4, cut out 12 circles from white card. I prefer using scissors when cutting circles but some people find it easier with a craft knife. Perfect circles take years of practice so don't worry if they look a bit wobbly— it all adds character! Then measure the height, width, and depth of your sides. Add 3mm (0.12 in) to your height all the way around the stage. Transfer these measurements to white card, cutting out pieces that will fit each side. Glue the other three sides you have made onto the back and sides of the stage

For a beautifully clean and tidy stagefront, cut the front edges from one long piece of card. To do this you'll need to measure and score the corners lightly with a craft knife.

Remember, inside corners need to be scored on the reverse of the card.

→ FINISHING OFF THE STAGE

Stick the circles—spaced evenly—to the reverse side of the card that will fit along the front side of the stage. The circles need be stuck so the top half of them can be seen over the top edge of the card. Finally, attach your front piece!

→ CUT OUT THE FACADE

Print Template 3 twice. Tape one version to white card and one to white 5mm (3/16 in) foamcore. Cut following the outside line for the card and the inside line for the foamcore and then glue the pieces together. Check your cutting blade is sharp before doing this.

→ NOW FOR THE FUN BIT

Use Template 4 to inspire the façade's details. Copy my design or feel free to invent one of your own. Cut this out of white card.

→ ADDING DEPTH

Shadows play an important part in a white paper sculpture. Without depth and shadows, lovely details easily get lost.

The best way to create depth is to use a heavy card stock but this can be difficult to cut, so a simple alternative is to cut multiples of the same shape out of a lighter stock, stick them together, and trim so they match up.

→ STICK THE DETAILS TO YOUR FACADE

Use tack instead of glue. The tack will raise the detail off the surface creating even more depth and shadows.

→ MAKING THE SCENERY

Tape Templates 5 and 6 to white card and using a craft knife, carefully cut out the two layers of scenery.

→ MAKE PUPPETS

I've designed some characters on template 7 on page 126, but I encourage you to imagine your own. Cut them from card before taping a white wooden stick to the reverse.

01 Tape Template 1 to white 5mm (3/16 in) foamcore and cut out the shapes using a sharp craft knife.

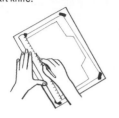

02 Glue the rectangles to the outside of the corresponding edges to make a 3D stage shape.

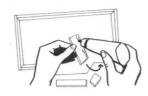

03 This platform will make up the base of your stage.

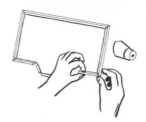

04 Secure the sides with hot glue all the way around. Make sure they are tight and flush to the edge.

05 Flip the stage over and tightly tape the sides to the base for extra support and stability.

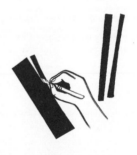

HOW TO MAKE
The Stage

06 Tape Template 2 to white 5mm (3/16 in) foamcore. Cut out the shapes with a sharp craft knife.

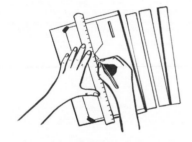

07 Glue the largest piece on top of your stage base. It should match exactly and the front and sides should be flush.

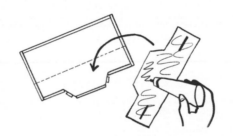

08 Cut some rough strips of card to be used as spacers.

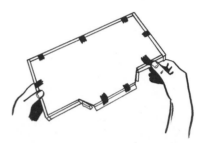

09 These spacers will determine the width of the slots needed for the scenery you will be making later.

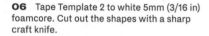

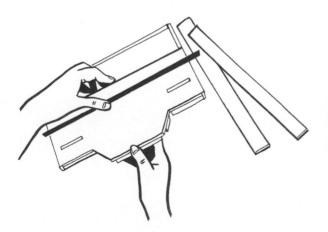

10 Glue the foamcore rectangles to the stage with the thinnest at the back, using the rough strips of card as spacers. Once the glue is dry, remove the spacer card.

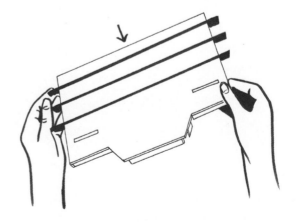

11 Flip your stage upside down and lay onto some white card. Draw around it with a pencil to create a new template.

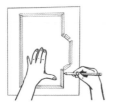

12 With a ruler and a pencil, mark every centimeter along the shorter sides of your stage on this template.

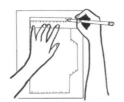

13 With a craft knife, cut 1cm (0.4 in) strips and then cut all the way around the outside pencil line to release the strips. These will be your floorboards.

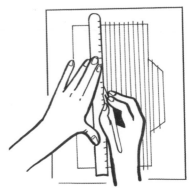

14 Glue the floorboards to the top of your stage base. Do not cover any of the slots or holes. I like to leave a small sliver of space between each floorboard to create a more 3D effect.

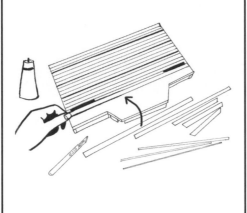

15 Cut out the circles on Template 4 from white card with a craft knife or scissors.

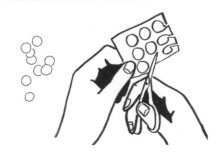

16 Accurately measure the height, width, and depth of the stage with a ruler and add 3mm (0.2 in) to the height.

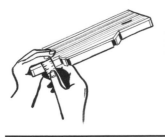

17 Using the measurements taken in Step 16 cut and score pieces of card to fit around your stage. The card should be 3mm (0.2 in) higher than the edges of the stage. Glue the sides on first...

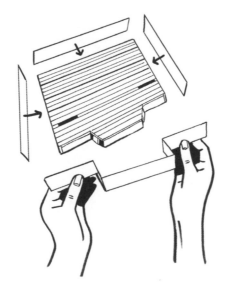

18 ...and before you glue on the front piece of card, stick your circles to the reverse of it, so they sit above the top edge.

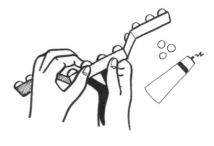

19 Finally glue this piece onto the front of your stage.

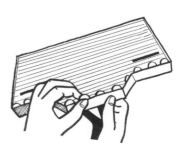

**TEMPLATES
pages 120–121**

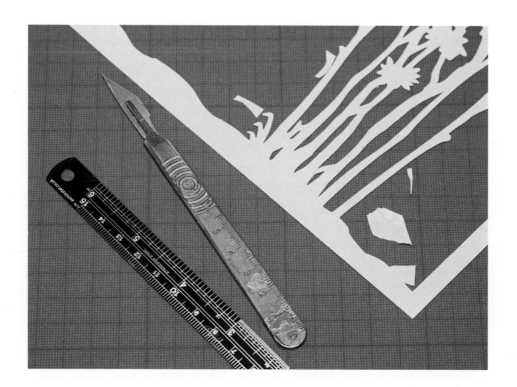

Say It with Paper

01 Print Template 3 out twice. Tape one version to white 5mm (3/16 in) foamcore and cut out following the inside line with a craft knife.

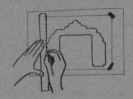

02 Tape the second Template 3 to white card and cut out, this time following the outside line with a sharp craft knife.

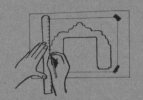

03 Glue the foamcore (from Step 1) to the card (from Step 2) to create your theater facade.

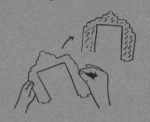

04 Use Template 4 to cut out all the details, and by all means add your own too.

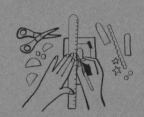

05 To create depth, cut out multiple versions of the same shape and stick them together.

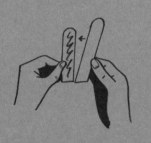

06 Instead of glue use tack to stick the details onto the facade. For guidance, refer to pages 52–53.

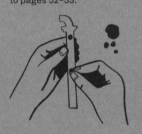

07 Some pieces can be tacked to the reverse of the facade to create more depth.

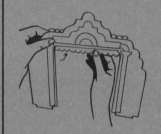

08 Tape Templates 5 and 6 to card and carefully cut out two layers of scenery.

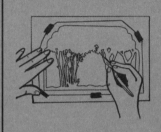

09 Next, slot the scenery into your stage. If the slots are too wide then tape a thin strip of artist's tape to the bottom of your two layers of scenery. This should pad them out a little and stabilize it all.

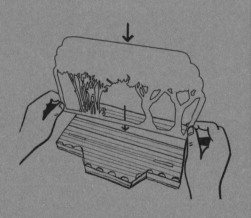

HOW TO MAKE
The Set

10 Now slot the facade from above into the two front slots.

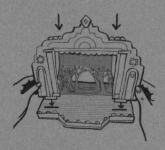

11 Cut out some characters and shapes from Template 7 to create your puppets or invent your own.

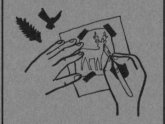

**TEMPLATES
pages 122–126**

12 Tape a painted wooden skewer to the back of the silhouette shapes so you can use them as puppets. Showtime!

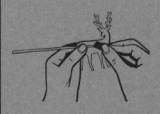

Silhouettes

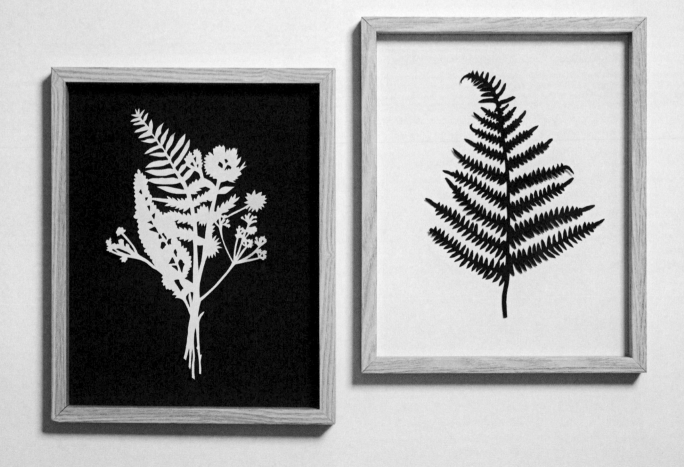

In 1922 Man Ray invented the "Rayograph." It is image–making based around placing objects on photographic paper in a dark room. Here's my paper homage!

→ **TIME TO GO OUTSIDE!**

Find a pretty leaf or collection of leaves and flowers. If you're going for a collection, tape the stalks together near the bottom so they stay together. Place your bunch or single leaf onto your photocopier or scanner, holding the lid down flat.

Photocopy the arrangement (test a few compositions). With a black pen, draw around the photocopy, exaggerating the shapes and filling in any bits that aren't clear. Lightly stick your photocopy, using a re-positionable spray mount to a paper of your choice (I've gone for simple black and white). With a sharp blade, use the photocopy as a stencil, cutting through the paper beneath. Once you have cut all the way around, release the photocopy and go over any parts that haven't cut through. Use scissors to round off any sharp edges of paper that would be better softer.

Find a contrasting color and carefully glue your cutout to it, leaving some areas unstuck so you can curl and fold and give your leaf or bunch more depth.

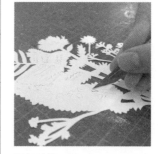
Cut out the shape.

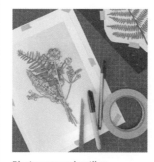
Photocopy and outline.

Gather leaves and arrange.

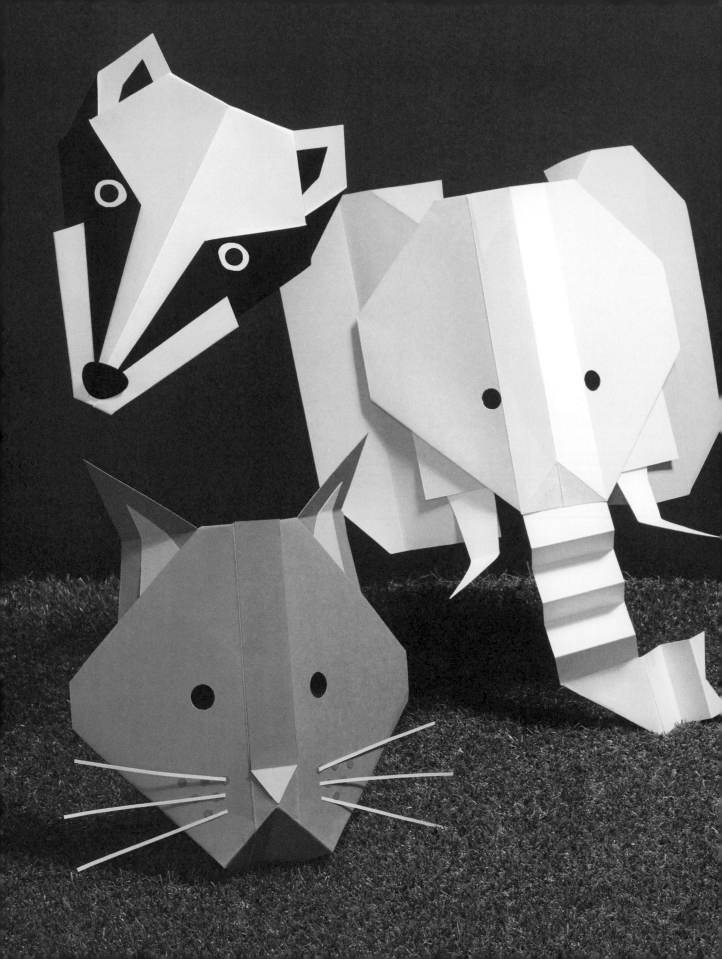

Meow

MAKE an animal mask

USE folds to create dimension

WORK with a bone folder

My cat, Iggy—bless his soul!

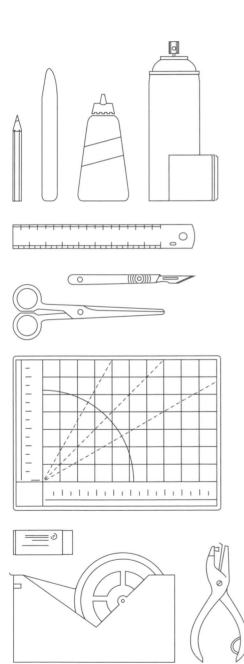

Difficulty

Allow ½ an hour per mask

I love animals. My cat, Iggy and I were best friends growing up. I'd spend hours and hours looking at his face, so I know exactly how to replicate it in paper. Every animal is beautiful in its own way, and dressing up as them is fun! Masks are one of the quickest and simplest things to make, so all you have to do is pick your favorite creature and get going. I've picked three to start with: a cat, an elephant, and a badger. (Apparently "Hatti" means elephant in Nepali!)

→ CHOOSE YOUR MATERIALS AND TOOLS

Find a range of colors in A3 (tabloid), cut into a square card, inspired by whatever animal you're making. A stiff card is probably best, about 260gsm (70 lb), so that the mask keeps its shape. You'll need a 30cm (12 in) ruler and a bone folder, a craft knife, gel glue, a hole punch, and some elastic.

If you're making the wolf (or badger), the trick is to stick two sheets of paper, about 120gsm (32 lb), together rather than using card. Find two contrasting colored sheets that match in size. With spray mount, cover one side of one of the sheets all over with spray (from a distance so you don't stain the paper). Make sure you have good ventilation and do this over a dust sheet or scrap sheet of paper.

Lay the second sheet on top, starting at the bottom end and slowly smoothing the sheet upward, so it sticks to the paper beneath. Watch out for air bubbles and make sure you smooth away with your hands, working from the center outward.

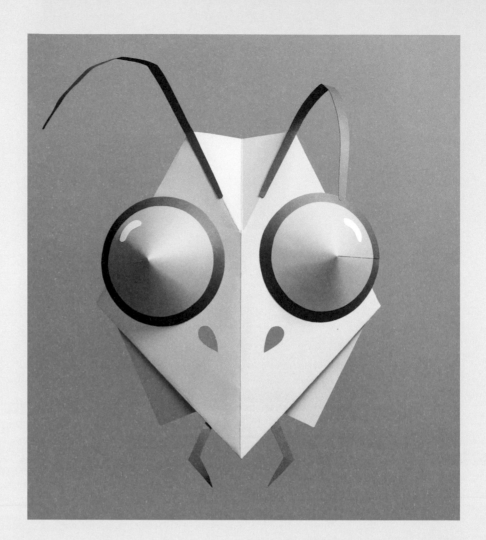

Invent your own mask! The badger can be adapted into a bug-eyed monster or a wolf. Just use different colors and customize the features.

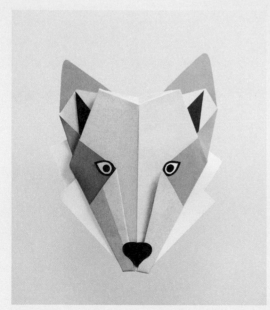

Use spray mount to stick papers together covering every inch of the surface otherwise the paper will bubble!

→ MAKE THE MASKS

Follow my drawings on pages 74–77, folding the square sheet first and then adding detail at the end. Because the masks are quick to make, why not try adapting my designs, adding more color, detail, or folds. Make a few!

→ FOLDING

When creating the folds, use the tip of the bone folder to make the score line, then fold and use the body of the bone folder to reinforce the score and strengthen the fold.

→ ADD ELASTIC

Once the mask is finished, measure some elastic around your head, making sure it's tight, but allow a small amount of excess. Attach both ends to the sides of the main body of the mask. There are a few ways to do this. If you have a stapler, staple the ends. You can also use a needle to thread the elastic through the card and make a knot. Velcro is a good alternative to elastic.

Thread elastic through the design to make it into a wearable mask!

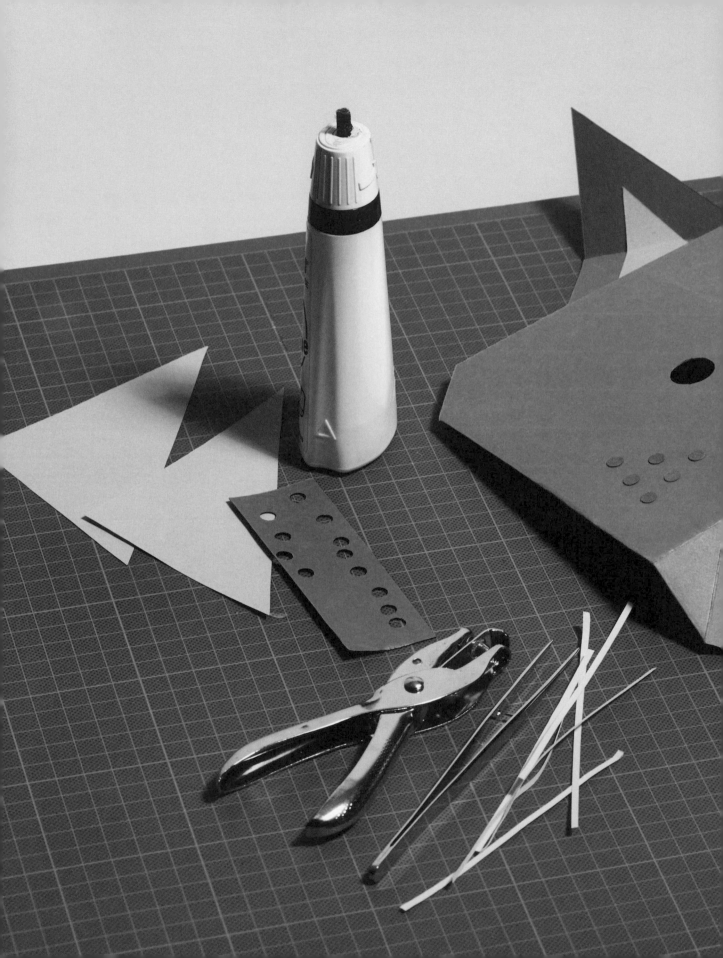

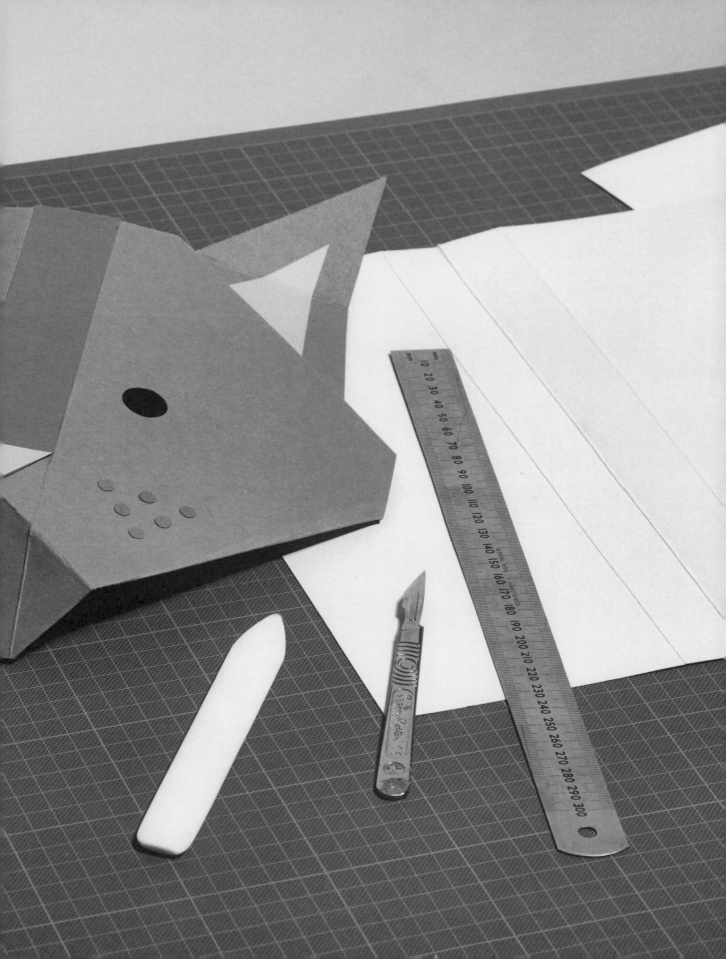

01 Cut a perfect square out of A3 (tabloid) orange card.

02 Fold in half, and lay it horizontally. Use your bone folder to crease.

03 With your ruler find the middle point on the top and bottom sides of the card.

04 Place your ruler in the center of these marks and score along each side of the ruler with the bone folder.

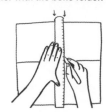

05 Flip your card over and fold all four corners inward so they meet the score lines.

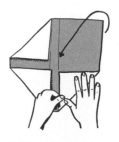

HOW TO MAKE
The Cat

06 Flip the card over again and fold the top two corners back on themselves, creating the ears.

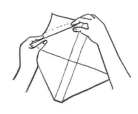

07 To create the mouth, find the center opposite the ears and score diagonally down with your bone folder.

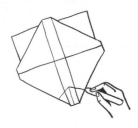

08 Fold the score lines inward.

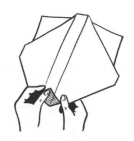

09 Fold the very top over so it is in line with the ears.

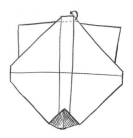

10 Using a craft knife, cut the eyes out on the horizontal fold line.

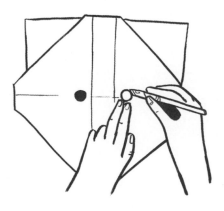

11 Add the detail. Make the ears bigger, create a nose, and add whiskers (see previous spread). Finally add the elastic to go around the head.

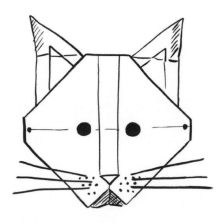

01 Cut a square out of A3 yellow card and fold in half, creasing the fold line before unfolding flat again.

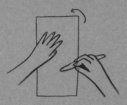

02 Make two score lines either side of the central crease. Use your ruler width.

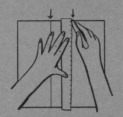

03 Fold and crease these lines with a bone folder.

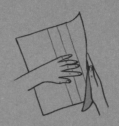

04 Flip your card over and fold the bottom corners in toward their nearest fold lines.

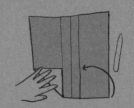

05 Next you need to fold the points back on themselves.

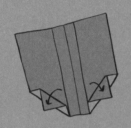

06 Fold the top corners in toward their nearest fold lines and flip over again.

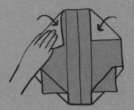

07 Carefully score diagonally from the center line to the bottom of the outer lines.

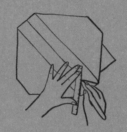

08 Fold the score lines inward and crease with a bone folder.

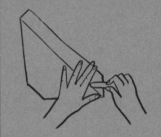

HOW TO MAKE The Elephant

09 Open out again and use your ruler to measure the width of this triangle.

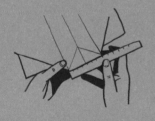

10 Cut a strip the same width and about the same length as the original square of card in matching yellow paper.

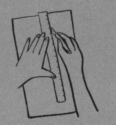

11 Make a concertina out of this strip of paper, folding every 3cm (1.2 in) to create the springy trunk.

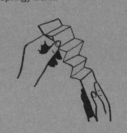

12 Cut the top and bottom ends as shown. Fold the concertina so the bottom half sits at a right angle.

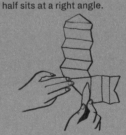

13 Stick the trunk to the mask with artist's tape and cut out the eye holes with a craft knife.

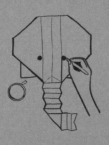

14 Use a square of card in another color to make the ears. Fold the corners as shown.

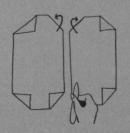

15 Attach them to the back of the mask without covering the eye holes.

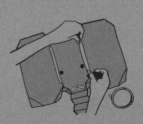

16 Finally, add details like tusks and elastic to go around the head.

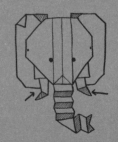

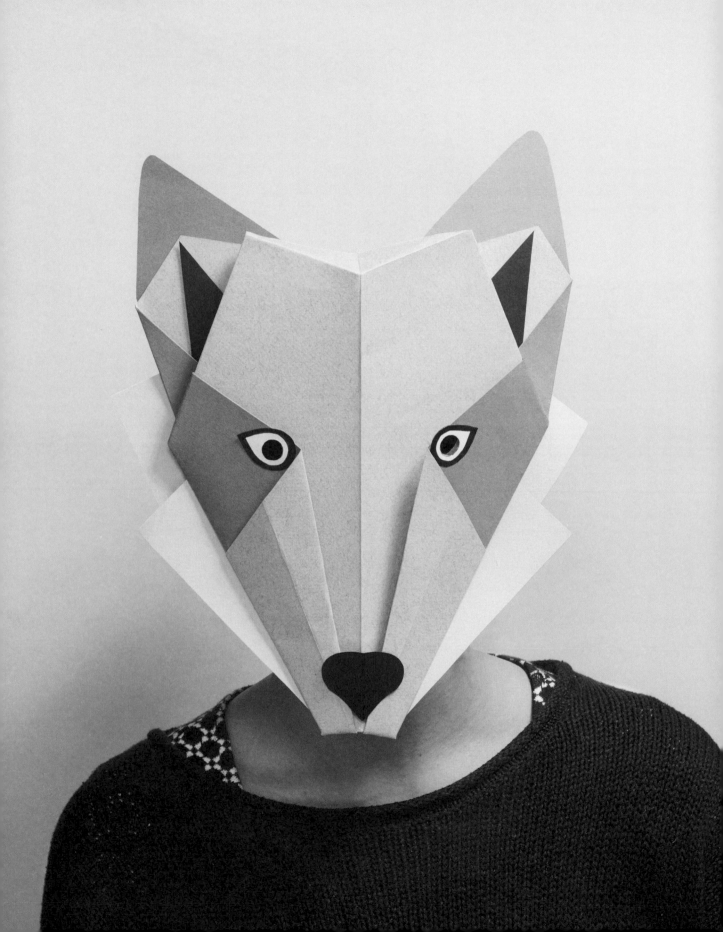

01 Cut two equal squares from A3 sheets of gray and white papers. Use spray mount to stick them together to create double-sided paper.

02 Fold and score this double-sided paper in half.

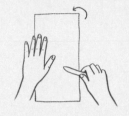

03 Fold the bottom right corner, diagonally and over the middle score line.

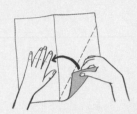

04 Lay it flat again, then do the same to the left side and again fold flat.

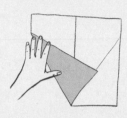

05 Fold the right side again and fold the corner back on itself so that it hangs over the diagonal edge.

HOW TO MAKE
The Badger

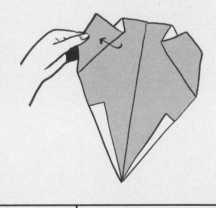

06 Do the same to the left side, scoring with the bone folder.

07 Flip the mask over and fold the overhanging bits around, as shown below. Stick to the back with artist's tape to secure in place.

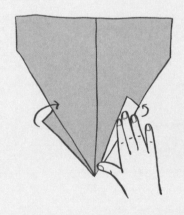

08 Fold the top corners over so each corner point reaches the middle score line.

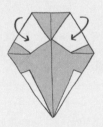

09 Fold each corner point back on itself to create the ear shape which we will return to in step 12.

10 Fold the excess paper top and bottom over and score flat with the bone folder.

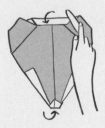

11 Flip the mask over and cut out the eyes with a craft knife, as shown.

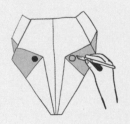

REFER TO
p66 for Badger
p76 for Wolf

12 Use extra black paper to add detail on the nose and ears. As with all the masks, add elastic to go around the head. Use these same steps to make the wolf seen on the facing page (just change the colors, eyes, and ears).

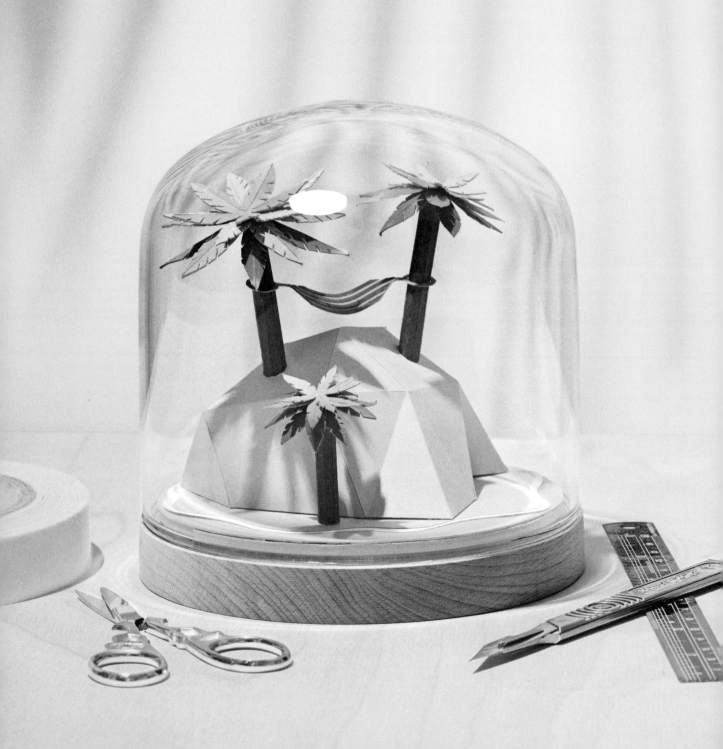

Relax

MAKE a miniature tropical island

USE glass domes

WORK a geometric technique

Just a few of the
wonderful buildings
from my holiday
to Panama in
2013. Inspiration
is everywhere, so
keep on snapping.

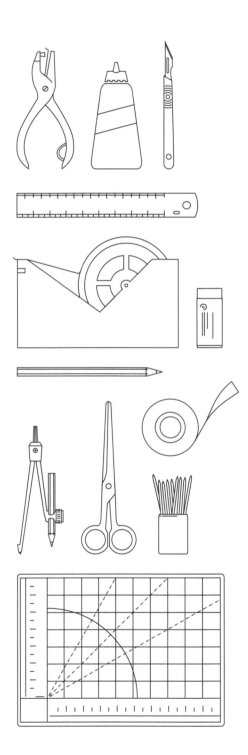

Difficulty

✂ ✂ ✂ ✂ ✂

Allow 1 day

Building a miniature model of a special place is a way to share a memory and create a truly personal sculpture. A few years ago I enjoyed the holiday of a lifetime in Panama. Tropical islands, unspoilt beaches, jungles, monkeys—a world away from my life in London. When I returned I found myself building little tropical islands, palm trees, and birds to remind me of the colorful places I'd seen. You can do it too, let me show you how.

→ GEOMETRIC TECHNIQUE

I often build geometric landscapes with a technique that requires lots of scoring and folding. It's essentially making shapes out of folded triangles, so it's a perfect method to build paper mountains and little islands. To work out the shape I'm after (in this case an island) I experiment with paper, a ruler, a craft knife, glue, and a compass. It requires a lot of trial and error, but I recommend you have a go if you want to create an abstract triangular shape of your own!

→ CHOOSE PAPER FOR THE ISLAND

The island itself needs to be constructed out of roughly 280gsm (72 lb) card and all the smaller elements should be made from 180gsm (47 lb) paper. If you're using realistic colors as I have done, select three different greens for the leaves, plus yellow, brown, sea blue, white, red, and orange paper.

→ PREPARATION

Photocopy the templates found on page 118 and cut around each section with scissors. Now attach each part to the top of the relevant colored papers with artist's tape. The template of the island itself is made up of lots of score lines so use the trick of covering the template completely in sticky tape. This keeps everything together, and stops it all moving around while you cut and score through.

01 Photocopy the templates on page 118 and cut out eight sets of leaves.

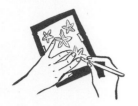

02 Cut tiny notches into the leaves. Score the dotted lines and fold.

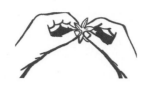

03 Stick four separate layers of leaves together, applying glue to the center of the reverse sides.

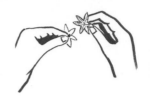

04 Now make the two trunks. Cut out a piece of brown paper about 8cm by 6cm (3.5 x 2.3 in).

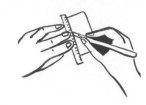

05 Carefully score a line every 3mm (0.12 in) using a blunt craft knife and a ruler.

HOW TO MAKE
The Palm Trees

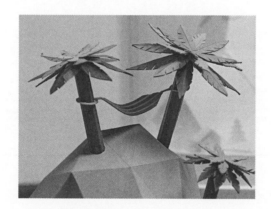

**TEMPLATES
page 118**

06 Apply an even amount of glue to the reverse side of the paper (the one without scores).

07 Roll into a cylinder—no bigger than 5mm (0.2 in) in diameter—and hold it in place until dry.

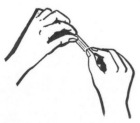

08 Glue the leaves to the top of the trunk by applying glue to the center of the reverse side.

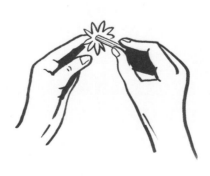

09 Give the leaves more volume by folding them up and down. Repeat from Step 4 to make the second tree.

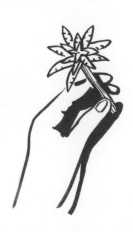

→ BUILDING YOUR TROPICAL ISLAND

First make two palm trees following the instructions on the facing page. Put them aside while you make the island's shape. I suggest using a craft knife with a blunt blade for scoring because the sculpture is so small. There's a lot of precise scoring involved in this task, so practice how much pressure you need to apply to your knife before working on the template. Pressing too hard might cut through the paper instead of scoring it, while pressing too lightly won't score the paper at all. Score all the lines on the front before scoring the reverse side.

To score the reverse, make a pin-sized hole through the template, either end of the dotted line, so you can see where to score when you turn the paper over. After scoring, cut out all the outside lines, pop out the shape, and gently fold all the scored lines. Punch out the circles with a holepunch. By this point, the template will be in pieces on your cutting mat, so use the image of the template in this book on page 118 to see where the holes should go. Double check that your tree trunks are narrow enough to fit through these holes. If they are too narrow, wrap some artist's tape around the bottom to give them more width.

I used a range of materials to create this tropical model. Can you spot the paper palm trees?

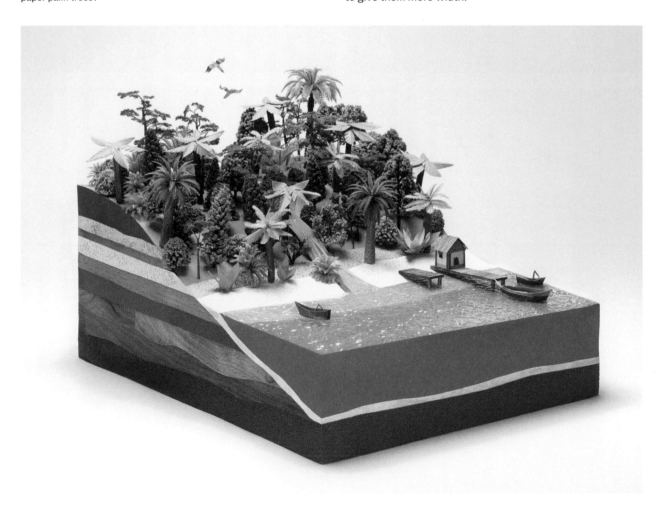

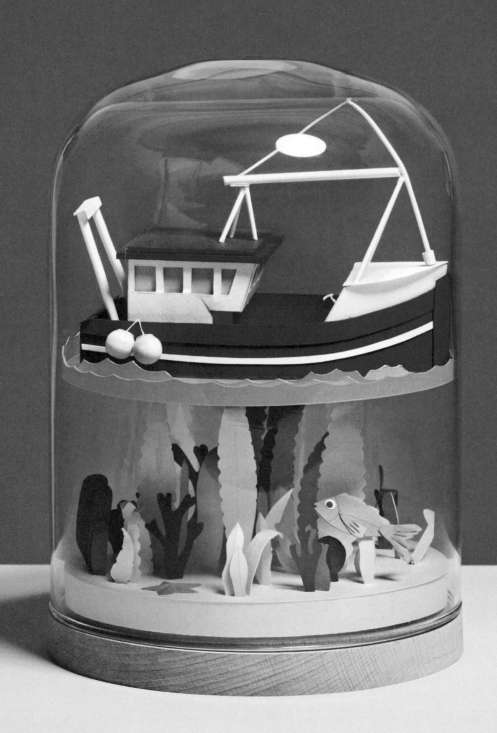

01 Find a glass jar to display the sculpture and measure the diameter of the inside base.

02 Photocopy the template on page 118 and tape each section onto your chosen paper.

03 Score folds with a blunt craft knife and a ruler, being careful not to cut all the way through the paper.

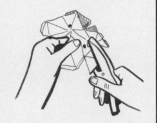

04 Make a pin prick either end of the dotted lines so you can see where to score on the reverse.

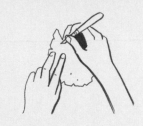

TEMPLATES
page 118

05 Having scored the reverse, cut through all the outside lines and pop out the shape.

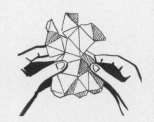

06 Gently fold all the score lines so that your shape becomes more 3D.

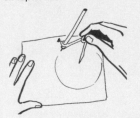

07 Use a hole punch to punch out two 5mm (3/16 in) circles. Refer to the original template to see the position of these holes.

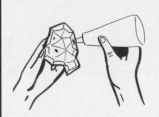

08 Construct the shape of the island by sticking the inside tabs to the corresponding triangles.

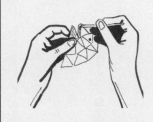

HOW TO MAKE The Island

09 While your island dries, use the template to cut out the shape of the yellow sand. Add a layer of white underneath to represent sea spray.

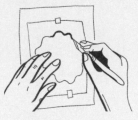

10 Using your measurements from Step 1, cut out a disc of blue paper to fit inside your display jar. Stick the yellow sand shape on top of this.

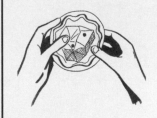

11 Apply glue to all the bottom tabs of your island shape and spread the glue evenly over them.

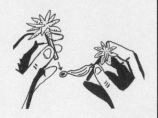

12 Glue your island to the center of your sand and sea base, and manipulate the tabs so they all sit flat.

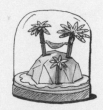

13 Using the template on page 118 cut the hammock out of your orange paper and add red stripes…

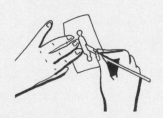

14 …and use a hole punch to cut out the circles on either end of the hammock to slot your palm trees into.

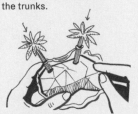

15 Slide your palm trees through the island holes. If the holes are too loose, wrap artist's tape around the trunks.

16 Lastly, place everything inside your jar; adding more palm trees if you can fit them in.

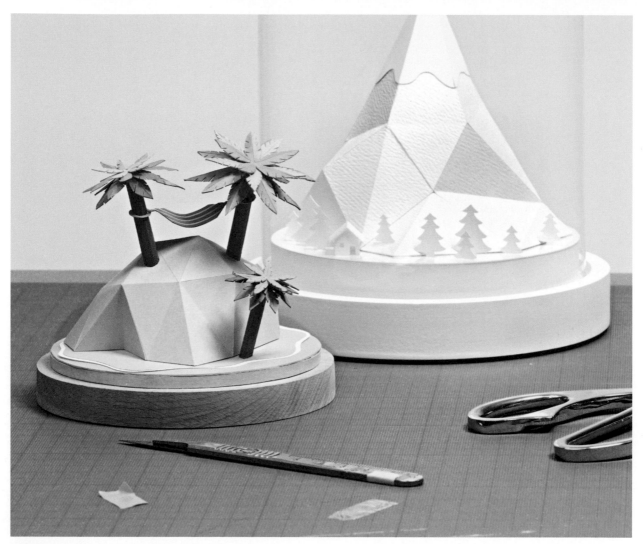

Behind my island is a snowy mountain I made in a similar style using textured paper.

Use sticky tape to rescue any rip you make in the paper. Just stick it to the reverse side so it can't be seen!

→ **TIME TO GLUE**

Apply glue to the tabs carefully with a toothpick to avoid mess! Start with the inside tabs and corresponding triangles, sticking them together and using bits of artist's tape to hold joins while they dry.

The reverse scores should fold the opposite way to the front scores. Cut your blue disc of sea to fit inside your display jar and stick the yellow sand layer on top. Now apply glue to the outside tabs of your island shape. When gluing down to the yellow base, make sure all sides are sitting flush to the paper floor. You may need to manipulate and jiggle it until it fits!

→ **ADDING DETAILS**

Make your little hammock using the template on page 118, punching the holes out before cutting out the shape. The tree trunks should be able to slide through the holes on either end. You can angle the trees.

→ **PUTTING IT IN PRIDE OF PLACE**

Finally place the sculpture inside your display jar and admire!

I use a blunt blade to score small sculptures, so the folds are crisp and neat. Score mountain folds on the top and valley folds on the reverse.

Go–go geometric!

When making geometric spheres, I'll always turn to the very beautiful pentakis dodecahedron. **Customize the shape with color and detail to turn it into different geometric objects.**

→ CREATING THE SPHERE

Photocopy the template on page 119. This will make a sphere about 6.5cm (2.5 in) in size. I recommend using a smooth 180gsm (47 lb) paper. As before, tape your photocopied template to your paper of choice to use as a guide. Carefully score and cut through all the lines, and use a toothpick to apply glue.

While the glue dries, lightly tape the joins with artist's tape to hold them tight. It takes about an hour to bond so I like to put on a podcast to listen to! Remove the artist's tape when dry. Now make and add all the fun details!

CRAFTY TIP #12

Try to imagine bizarre things you might make from a pentakis dodecahedron. Give it a go-go!

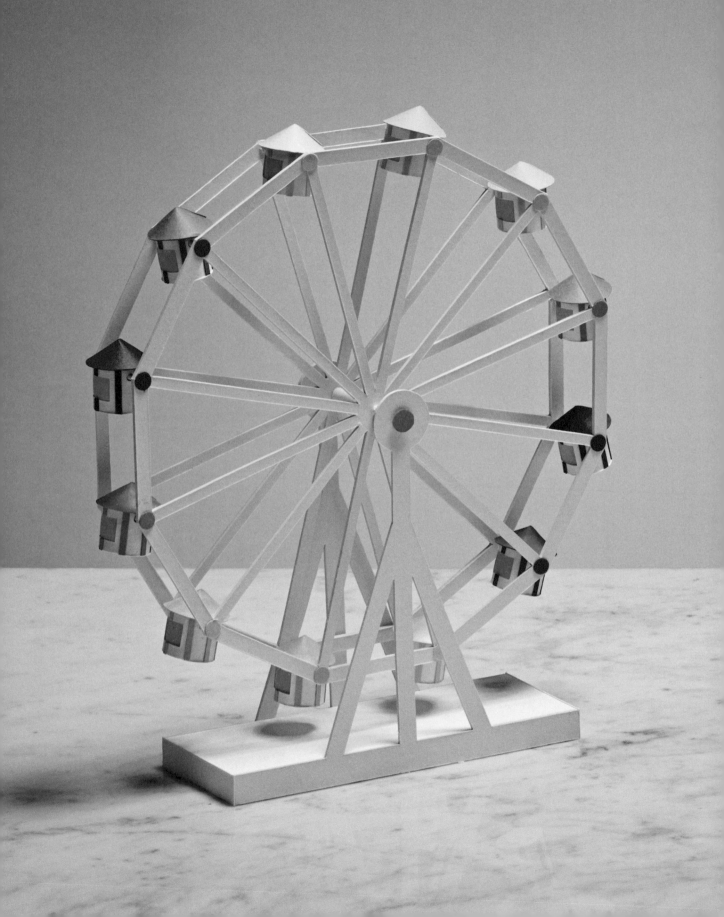

HOW TO SAY # Roll Up!

MAKE a miniature Ferris wheel

USE tiny spindle mechanisms

WORK with many parts

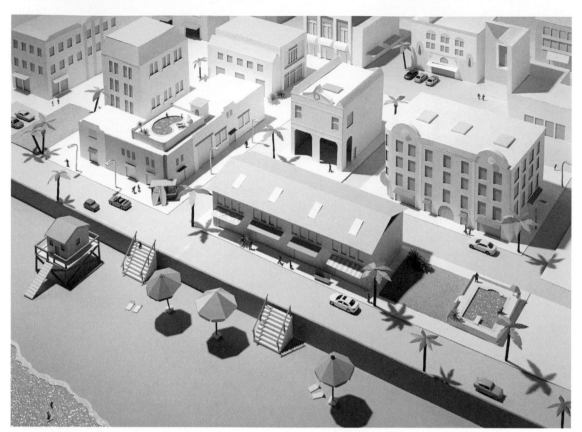

A still from a paper set I animated. It's Miami, USA.

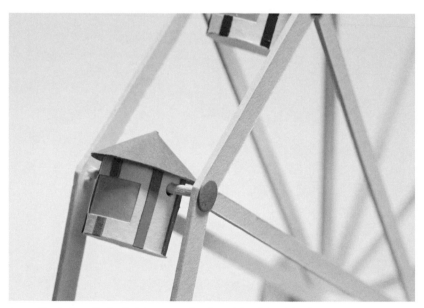

Camouflage where the toothpicks suspending the cabins sit by gluing the hole-punched circles over the holes made in the card wheel.

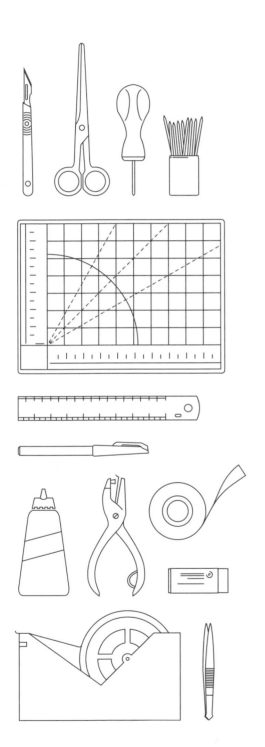

Difficulty

X X X X X

Allow 1 day

Making things move is fun. It's easy to forget that animations are just lots of pictures shown quickly one after the other. Sometimes at the end of a photo shoot the photographer and I will mess around with my set, moving things and taking a picture, moving them again and taking another picture. Then when we play them back quickly, it's, "Hey presto! We've made a movie!" So once you have finished this Ferris wheel you could photograph it yourself at various stages and make your own animation.

→ CHOOSE YOUR MATERIALS
You will need an A4 150gsm (40-lb letter) sheet of white paper and six different colored papers. Also, card, 5mm (3/16 in) foamcore, 2mm (0.08 in) board, a white marker pen, one wooden skewer, and a handful of toothpicks. A hole punch and a sharp pointed tool like an awl are also necessary, as well as the usual tools like a ruler, a craft knife, tweezers, artist's tape and gel glue.

→ PREPARE YOUR TEMPLATES
Templates are on pages 115–117 and the instructions are on pages 97–99. Tape each template to its correct material and color, ready to be cut through. I'm using six colors for 12 cabins. Some templates need to be photocopied twice.

→ PUNCH HOLES
Before you cut anything out, start by punching holes in the 2mm (0.08 inch) board wheel parts and stands with a sharp point like an awl. Later on, toothpicks will need to slide through the small holes, and a wooden skewer through the bigger holes so make sure they are big enough for these.

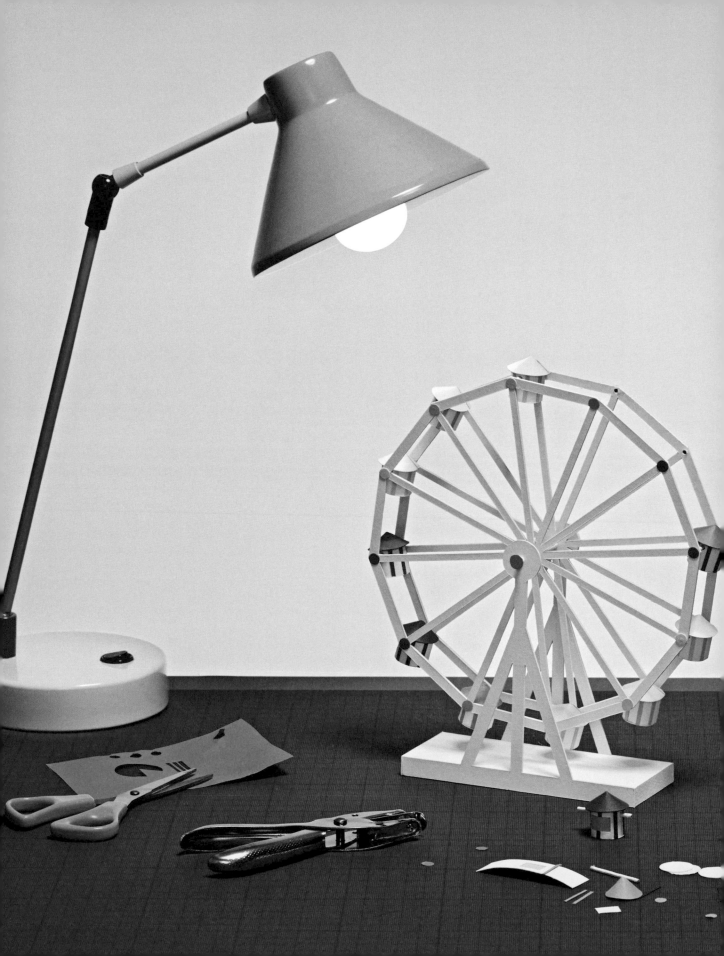

→ CUT THE PARTS FOR THE STRUCTURE

Cut out wheel parts and stands from 2mm (0.08 in) board accurately with a sharp craft knife. Cut the base rectangles from foamcore and glue together, one on top of the other. Once dry, the t stands should be glued to the long sides of the foamcore base, so they match up and sit opposite each other. Cover the top and sides of the base with white paper.

→ MAKE YOUR SPINDLE

Paint a wooden skewer white with a white marker pen and trim to match the length of the template. Now cut the "spindle cover" from paper, cover in glue, and roll it around the center of your wooden skewer, holding tight until it's dry. Now it will act as a spindle. Slide it into the central holes of your wheels, one wheel on either side, and push them in until they reach the roll of spindle cover paper.

→ INSERT THE WHEELS INTO STANDS

Fit the ends of your spindle through the stand so that the wheels are now suspended above the base. The wheels should be able to spin around, so give it a little go!

CRAFTY TIP #13

Dry beans make very useful little weights. I glue them inside small 3D shapes to help them hang nicely straight.

→ PREPARE THE PARTS FOR THE CABINS

Return to your cabin templates, taped to their relevant colors. Before cutting, punch all the small holes with an awl, so they are big enough for a toothpick to slot through. Cut out 12 white exteriors, 12 blue windows, and 12 roofs in your six colors (two of each) and the stripes (seven stripes per cabin in the six colors, so two lots of each to cover all 12 cabins). All from paper. Some lines need to be scored.

→ BUILDING A CABIN

On the front side of your flat cabin pieces, decorate with seven colored stripes, evenly spaced, and then trim so they are flush to the white paper and do not obscure the window. Use tweezers to help you glue and stick the stripes neatly. Stick a small blue window to the reverse of the cabin exterior so that it covers the window hole. Fold the score line and glue the ends together to make a cylinder. Glue a base to the bottom.

I like to glue a little weight to the bottom of the interior so that it sits the right way up when hanging. A dry bean makes a cheap, easy weight that should do the trick! Take a pre-cut roof shape, in a matching color to your decorative stripes. Fold and glue into a shallow cone. Glue all over the reverse and stick to the top of your cabin and leave to dry.

→ ADD TO YOUR WHEEL

Paint a toothpick white and trim, referring to your template on page 116 for the correct length. Make sure the ends are cut cleanly and not at an angle. Slide the stick through the two holes in your cabin. The fit needs to be quite loose and central. Now add a little glue to the ends of the toothpick and insert into one pair of facing holes in your wheels. The ends of the toothpick should be flush with the outside of the wheel and not stick out. If they do then trim off the excess. Repeat until you have 12 multi-colored cabins hanging from your Ferris wheel.

→ FINISHING TOUCHES

Punch 12 circles from your six different colored papers (two of each color). Using tweezers and glue, stick the little circles around your wheels, covering the holes where the toothpicks sit. Make slightly bigger circles (I've used blue paper) and stick them to the center where the spindle is. Voila! Your own miniature, moving Ferris wheel! Now try animating it by taking a series of photographs as you spin it slowly round.

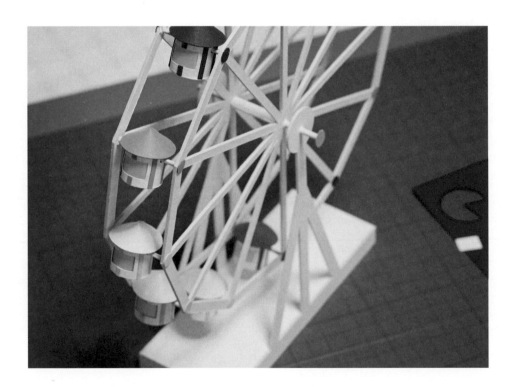

Say It with Paper

01 Tape the wheel and stand templates down onto 2mm (0.08 in) board.

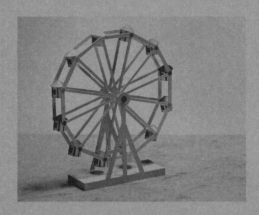

02 Punch 12 small holes around each of your wheels, big enough for a toothpick, using an awl. Then cut out both wheels.

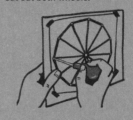

03 Punch out the two larger holes in the top of each wheel stand, wide enough for a wooden skewer to slide through. Then cut out each stand.

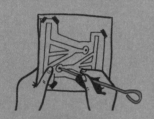

04 Photocopy the base template three times and tape two to foamcore and one to paper. Cut out the three shapes.

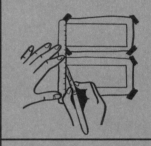

05 Glue the two base foamcore pieces together.

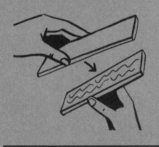

06 Cover the top of the base foamcore in paper. The base sides should be cut from white paper and also glued. Then glue the stand to the long sides of your base.

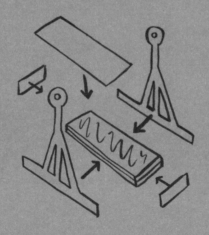

TEMPLATES
pages 115–116

07 Photocopy the spindle paper cover template and cut out with a craft knife.

08 Paint a toothpick white and trim referring to the template for the length.

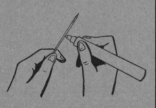

09 Roll your paper spindle cover and glue it around the center of your wooden skewer.

10 Now insert each end of your spindle into the central hole of each wheel until it reaches the middle roll of paper.

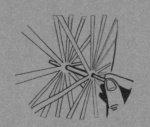

11 All the parts of the Ferris wheel should fit together like so.

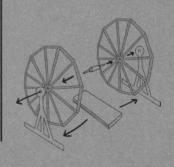

01 Tape the cabin templates to white paper and punch holes into the circles before cutting out.

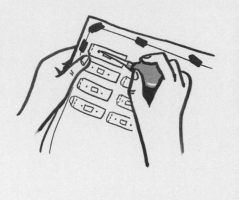

02 Tape the rest of the templates to a combination of your six colored papers and cut out using a craft knife.

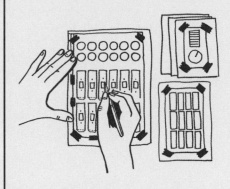

03 Cut seven colored stripes for each cabin and delicately glue to your cabin exterior.

04 Flip the cabin exterior over and trim the stripes so they are flush to the edge of the exterior and do not obscure the window.

HOW TO MAKE

The cabins

05 Stick the cabin windows to the reverse of your cabin.

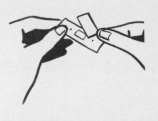

06 Fold the score line, roll and stick together to make a cylinder-shaped cabin.

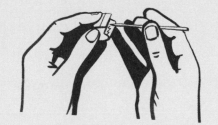

07 Glue a white circle to the bottom of each cabin structure, applying glue to the edge of the card.

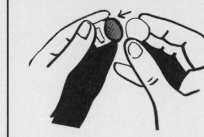

08 Stick a small weight inside. I like using dried beans.

09 Make a cone cabin roof in a corresponding color to the stripes.

10 Glue the roof to the top of your cabin structure.

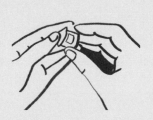

11 Paint 12 toothpicks white and trim to size, referring to the template on page 116.

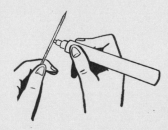

12 Slot each toothpick through the holes in the cabins, and make sure they sit centrally.

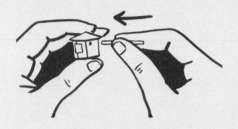

14 Repeat Steps 3–13 11 times so you have 12 multi-colored cabins.

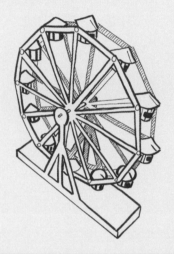

13 Slot each cabin on a toothpick into one the of 12 holes on each of the wheels.

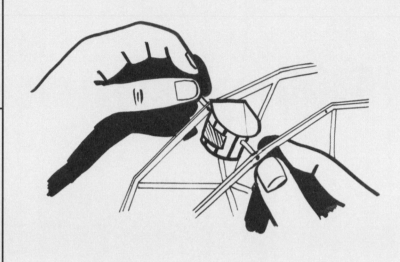

TEMPLATES page 117

15 Punch circles in your 12 colors, 2 for each color.

16 Cover the little holes where the toothpicks sit with your punched circles, one on each side of the wheel.

17 Cover the central spindle/wooden skewer holes with a circle too. Now you can start turning your Ferris wheel and photographing it!

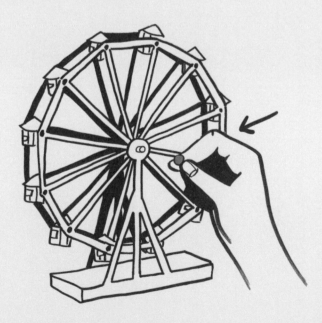

LITTLE LESSON #04

Happy snapping!

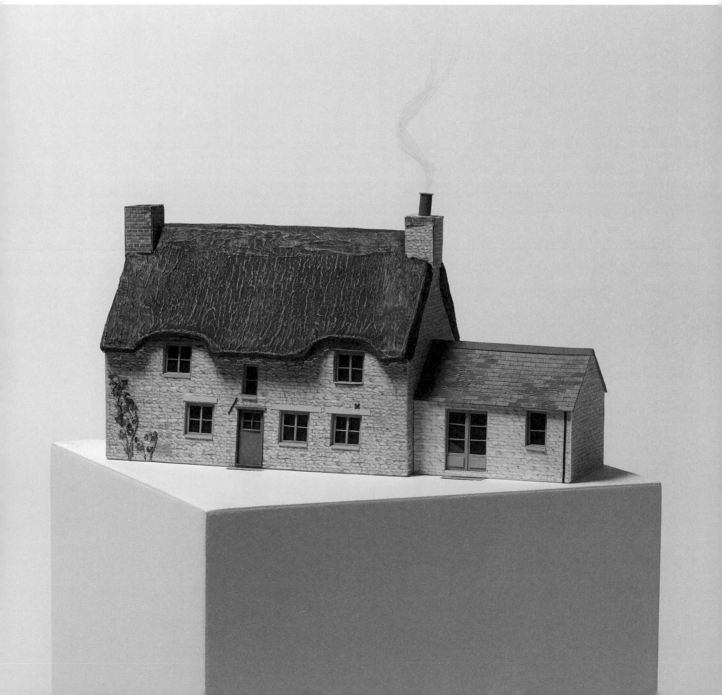

If you don't have all the fancy photography equipment, then a phone camera is the next best thing and it's a great tool for taking pictures of your finished paper sculptures. Here are a few handy hints to taking a professional-looking photograph.

→ FIND A SURFACE
Use a flat table against a wall that has plenty of natural light, so preferably near a big window.

→ GET THE LIGHTING RIGHT
It's impossible to control the weather, but I find a bright day with cloud cover the best for photographing paper craft without professional lights. Direct sunlight or lamplight will give really hard shadows, which can look really graphic, but often confuses the light balance in your phone and makes for an ugly picture. Try diffusing hard light with tracing paper to give you softer shadows.

→ MAKE THE BACKGROUND
Find a big sheet of paper, in the color of your choice. A neutral color like white is a safe bet, or choose a bright color that will complement your paper model. For a horizon line, stick one sheet to the wall and lay one on the table. If you don't want a horizon, create a scoop of paper by sticking one side to the wall and the other to the front of the table (flexed in the direction of the paper grain).

Try to blow away any dust and smooth away any lumps and bumps. It makes a huge difference!

→ SNAP!
Place your sculpture in the center, facing the light source, and filling the camera frame with your background. Focus your camera on the sculpture and take pictures from a number of different angles so that you can decide which one you prefer when you scroll through later.

CRAFTY TIP #14

Place your model on a box or plinth in front of a clean white wall for a more dramatic effect.

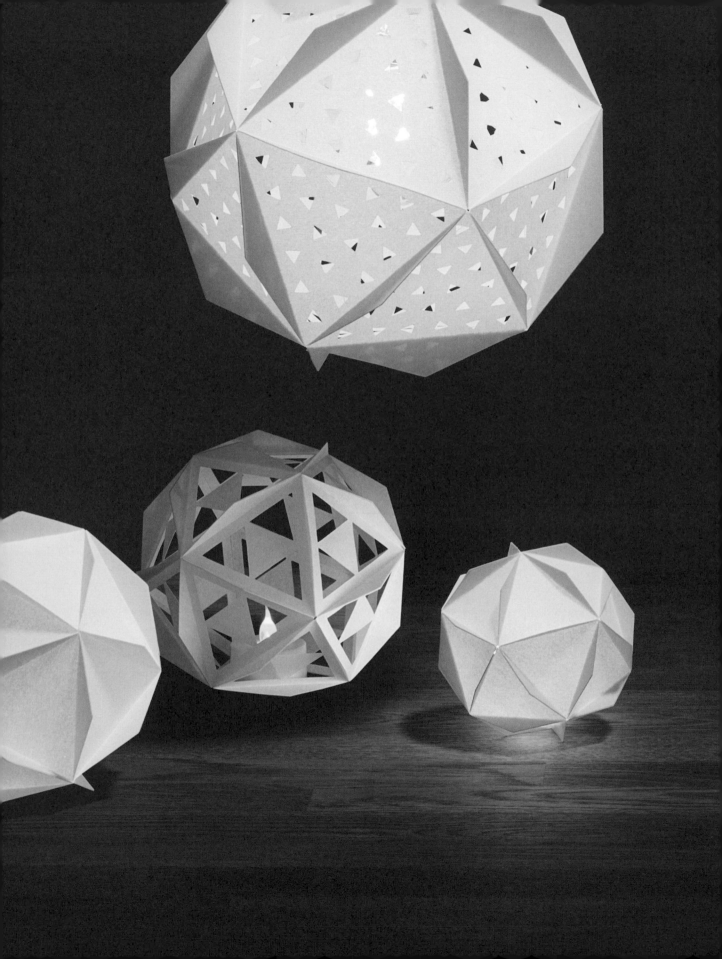

HOW TO SAY **Goodnight**

MAKE a simple paper lantern

USE light effects

WORK with multiples

The Festival of Light is the place to find incredible lanterns in every shape and color.

Find an LED candle or for a bigger lantern fill it with battery-powered fairy lights.

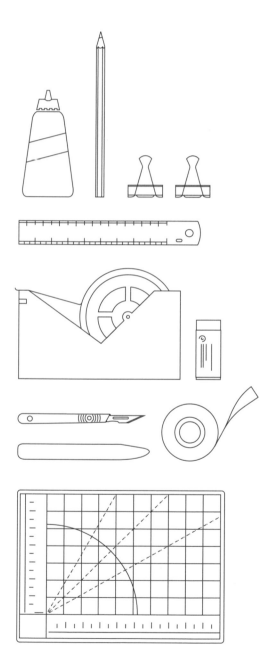

Difficulty

Allow 2–4 hours

Paper and light are perfect companions. The thinner the paper, the more it will glow when a light is placed behind it. The traditional paper lantern has a long history, stretching all the way back to ancient China. Each year the *Festival of Light* takes place all over the world, showcasing millions of beautiful variations on the traditional lantern. Let's start simple and build a small paper orb to sit on your table and light up the evening.

→ CHOOSE YOUR MATERIALS

Start by finding a small LED candle similar to the one on the page opposite. Use 180gsm (47 lb) paper, which is strong yet translucent when a light is shone from behind. I also recommend a coated paper that can be used with super glue. If you plan to use electric light, only use special lampshade paper (which you can find online) and never use a candle with a real flame! Have a handful of folio clips ready. They will hold the parts together while they dry so you don't have to.

→ PHOTOCOPY THE TEMPLATES

You will find the templates for this lantern on page 127. Reproduced at this size, the template will give you an orb 13cm by 13cm (5.12 x 5.12 in)—feel free to scale up to make it bigger especially if you have a large LED candle (the candle base needs to be smaller than one triangle). Print out four copies of the templates. Tape these to your chosen paper.

01 Photocopy the templates on page 127 four times. Tape to your paper, score, and cut out 19 shapes.

02 You will need 19 triangles in total. Fold all the score lines.

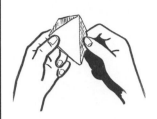

03 Apply glue evenly to the top of the scored tabs.

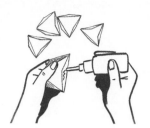

04 Stick a tab onto another piece so they match up.

HOW TO MAKE

The Lantern

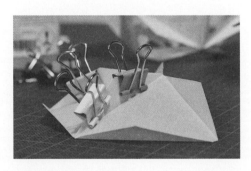

05 It can be a little fiddly at first, but use folio clips to keep the joins together while they set dry.

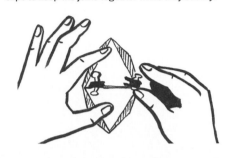

TEMPLATE
page 127

06 Repeat until you have created the shape of a pentagon using five triangles.

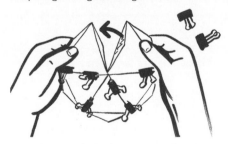

07 Make three pentagons in total. You will have four triangles left over. Remove all the folio clips when the glue is dry.

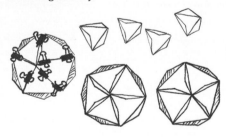

08 Now apply glue to a tab…

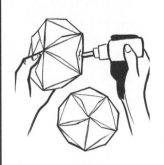

09 …and glue two pentagons together, again using folio clips to hold them in place.

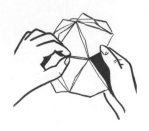

10 Glue the third pentagon on. You will notice there are five spaces. One space needs to be left empty.

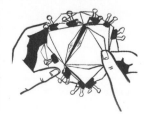

11 Glue the four spare triangles into four of the spaces, leaving one last empty space, which will form the base.

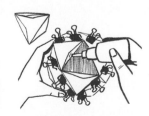

12 Once the glue is dry, remove the clips, switch on your LED candle, and place the paper orb over the candle.

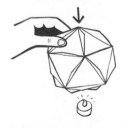

Nothing beats a folio clip when it comes to holding parts together while they dry.

→ ADDING DETAIL

If you have a bit more time, draw some simple, graphic detail onto the triangle templates. For example, lots of little triangles or circles (which are easier because you can use a holepunch). Use a sharp blade to cut through your template and chosen paper beneath.

→ TEST YOUR PRESSURE

Before scoring the dashed lines, test the pressure with a craft knife on some scrap paper. You need the right amount of pressure to cut through the template and score the paper beneath, but without cutting it.

→ SCORE YOUR LINES

Once you're happy, score all the dashed lines and cut out the solid lines with a craft knife so you end up with 20 shapes. You need 19 so you have one spare. Fold the score lines to create the tabs. If you accidentally cut through, use sticky tape on the reverse side to stick the line back together.

→ START STICKING

Separate the triangles into three groups of five, with four triangles left over to use later. One group at a time, apply glue to the reverse side of a tab and stick it to a tab on another triangle so they match up. Hold in place with one or two folio clips. Stick another triangle on and repeat again and again until you have made the shape of a pentagon with all five triangles. Make two more pentagon shapes with the other two groups of five. Remove the folio clips once dry.

→ MAKING THE ORB

Stick the three pentagon shapes together to create an orb, applying glue to one tab at a time and using folio clips to hold everything. Once these are together, you will notice there are five spaces left for triangles. Fill four of them with your spares and leave one empty. The empty one will form the base of the orb where you will place the LED candle.

→ WATCH IT GLOW!

Switch on your LED candle and place the orb over the top of it. Make a few in different sizes to create a lovely centerpiece. For larger lanterns I prefer to use strings of battery-powered fairy lights which have several benefits. They often produce a brighter glow, and as they are malleable, they can fit into a variety of shapes and sizes. Remember, safety first! Turn off the LED when you're done.

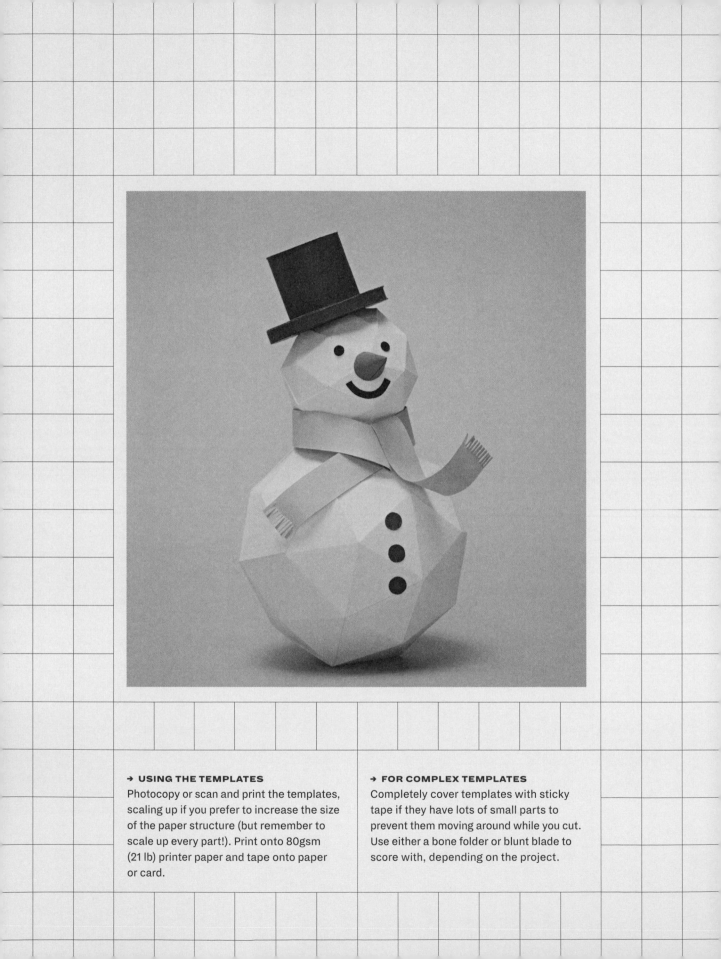

→ USING THE TEMPLATES
Photocopy or scan and print the templates, scaling up if you prefer to increase the size of the paper structure (but remember to scale up every part!). Print onto 80gsm (21 lb) printer paper and tape onto paper or card.

→ FOR COMPLEX TEMPLATES
Completely cover templates with sticky tape if they have lots of small parts to prevent them moving around while you cut. Use either a bone folder or blunt blade to score with, depending on the project.

A GUIDE TO

Templates

CUT ALONG LINE

SCORE + FOLD

SCORE ON REVERSE

PUNCH OUT HOLES ⊗ ⊗ ⊗

INDICATES WASTE

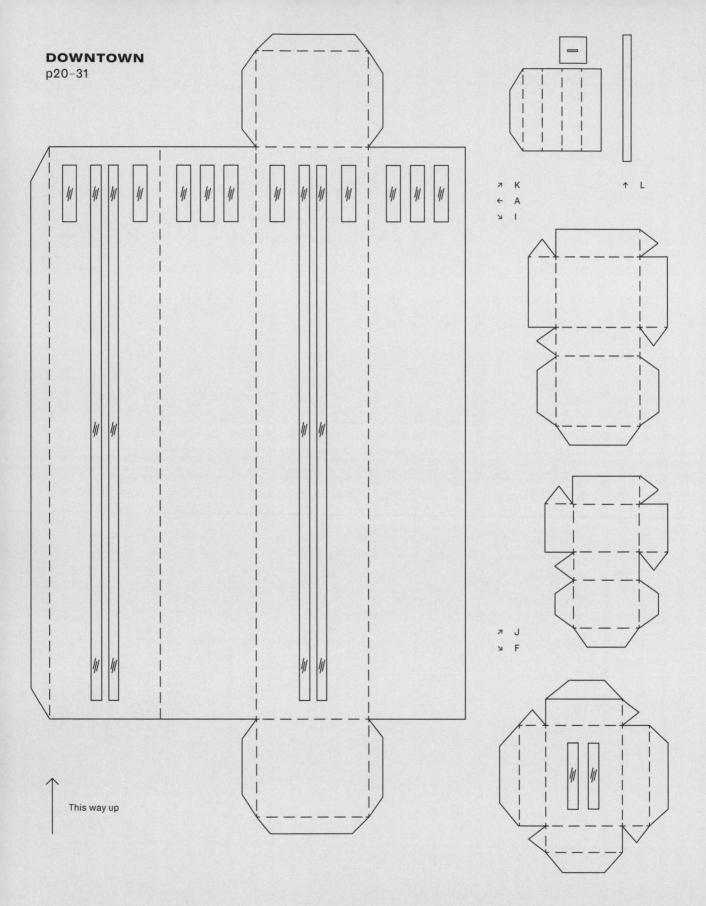

This way up

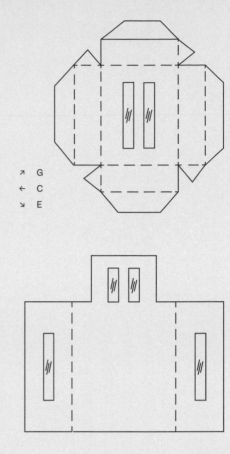

↗ G
← C
↘ E

↑ B
→ H
↓ D

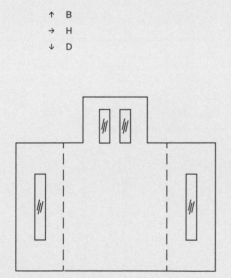

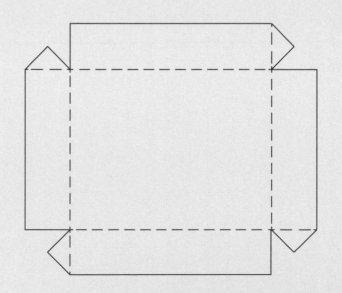

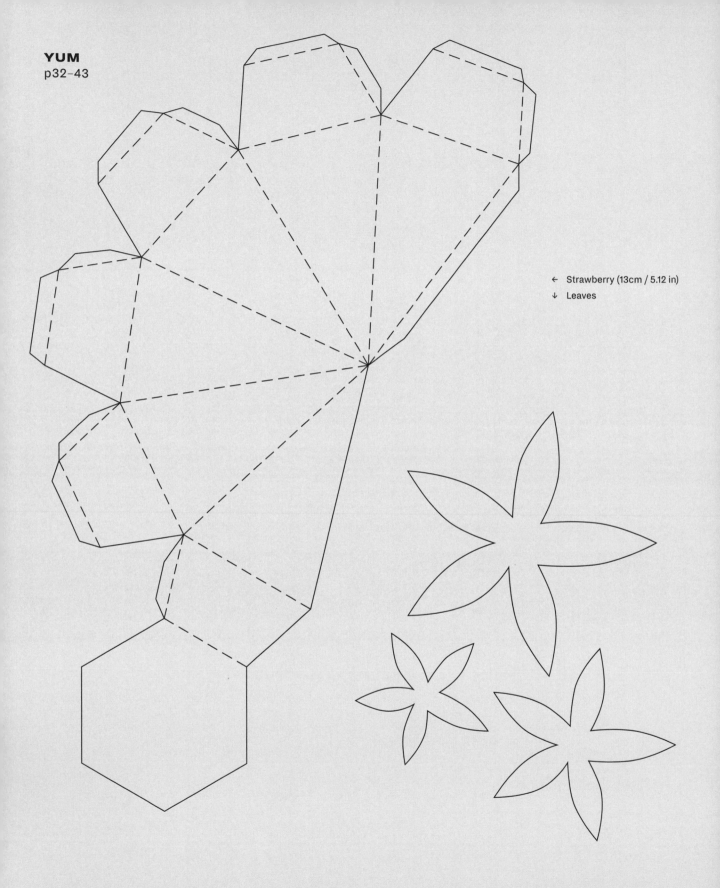

← Strawberry (13cm / 5.12 in)

↓ Leaves

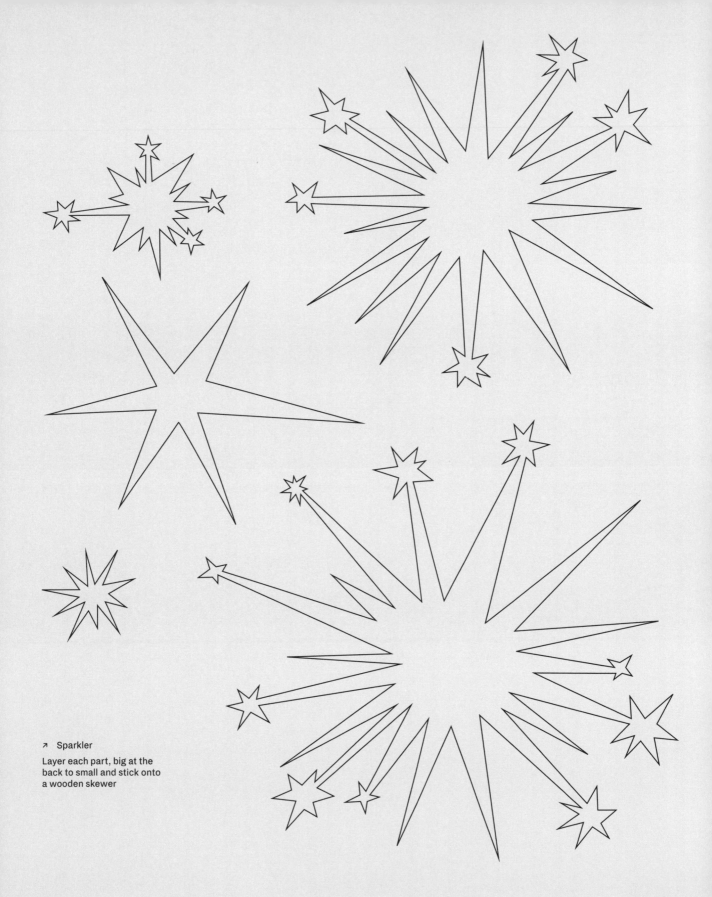

↗ Sparkler

Layer each part, big at the
back to small and stick onto
a wooden skewer

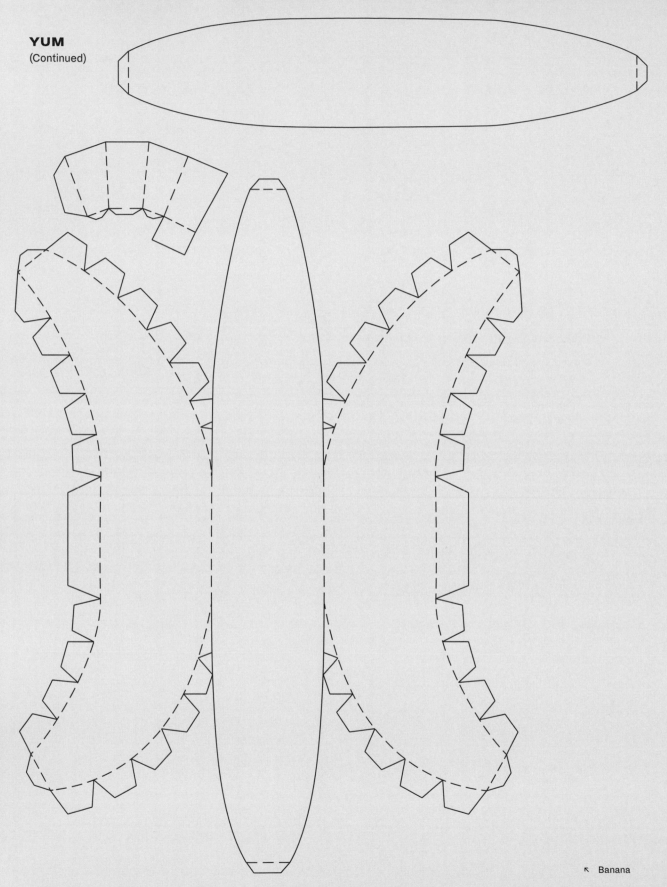

↖ Banana

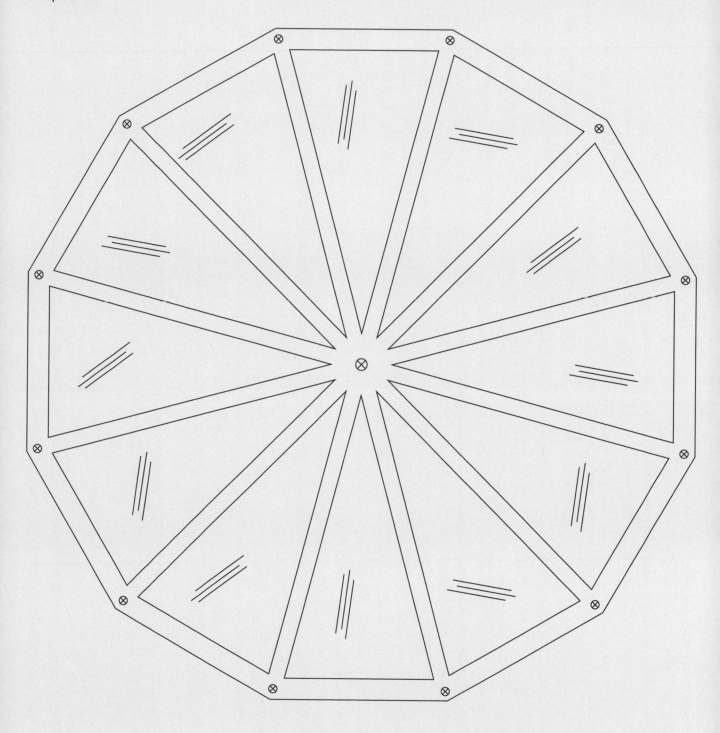

↗ Wheel × 2

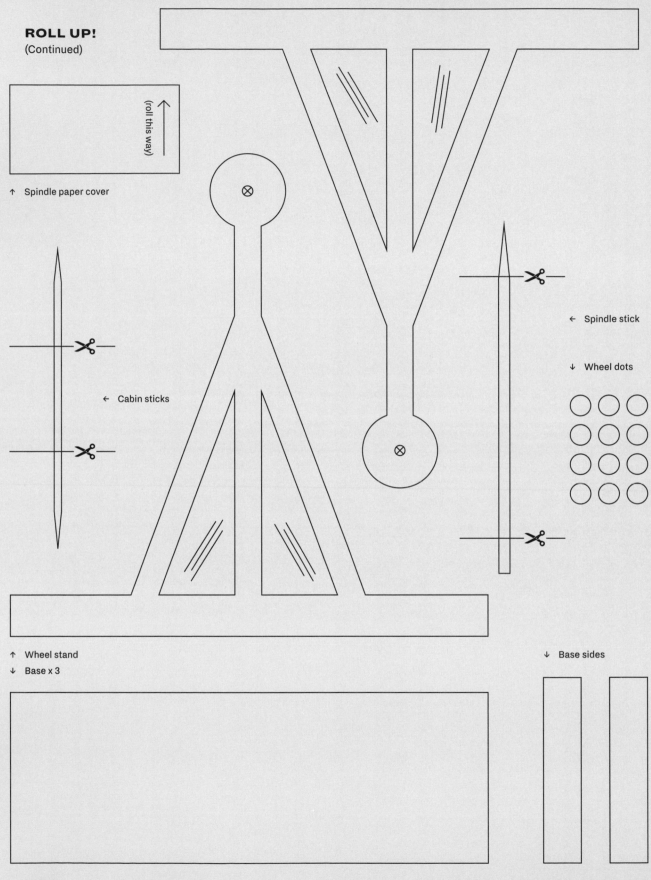

ROLL UP!
(Continued)

(roll this way)

↑ Spindle paper cover

← Cabin sticks

← Spindle stick

↓ Wheel dots

↑ Wheel stand
↓ Base x 3

↓ Base sides

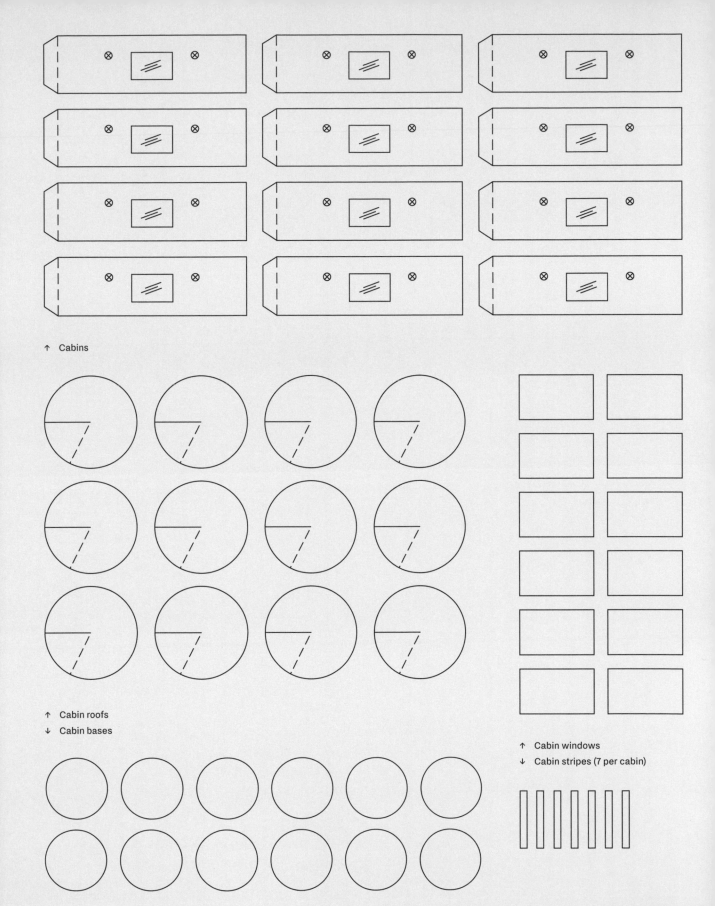

↑　Cabins

↑　Cabin roofs
↓　Cabin bases

↑　Cabin windows
↓　Cabin stripes (7 per cabin)

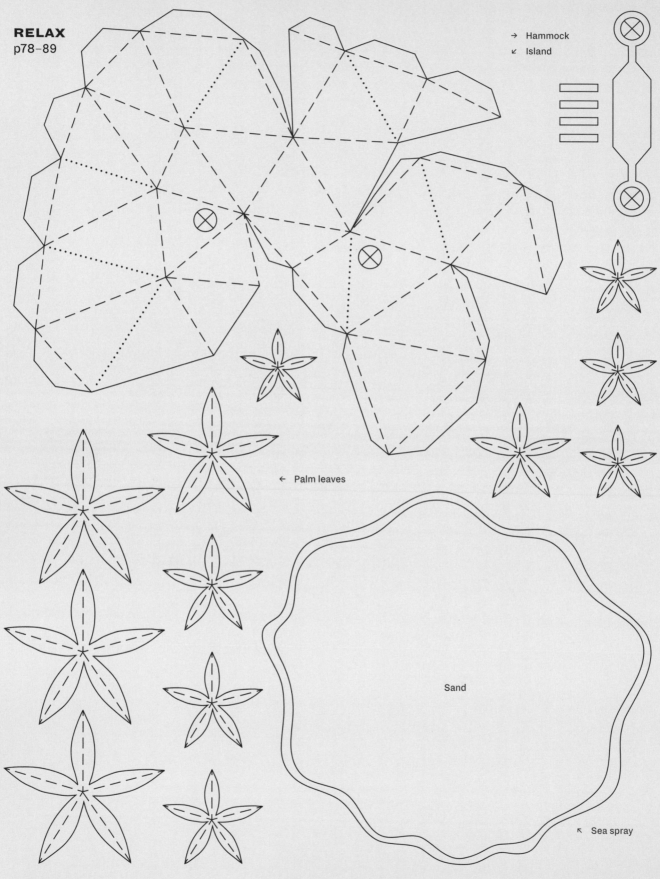

→ Hammock
↙ Island

← Palm leaves

Sand

↖ Sea spray

Say It with Paper

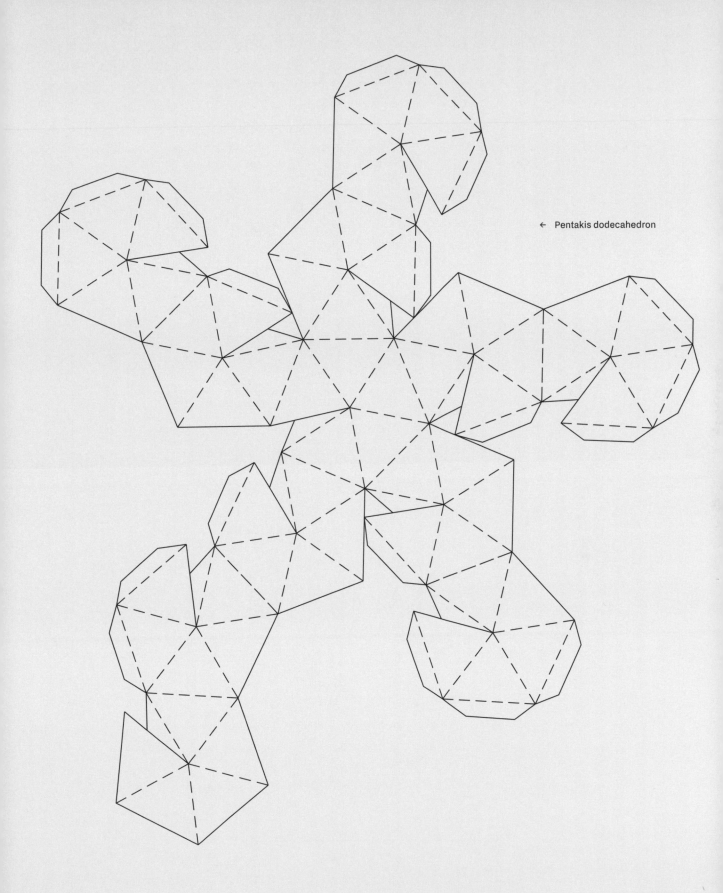

← Pentakis dodecahedron

↖ A

← C x 2

Outer line: for the paper
Inner line: for the foamcore

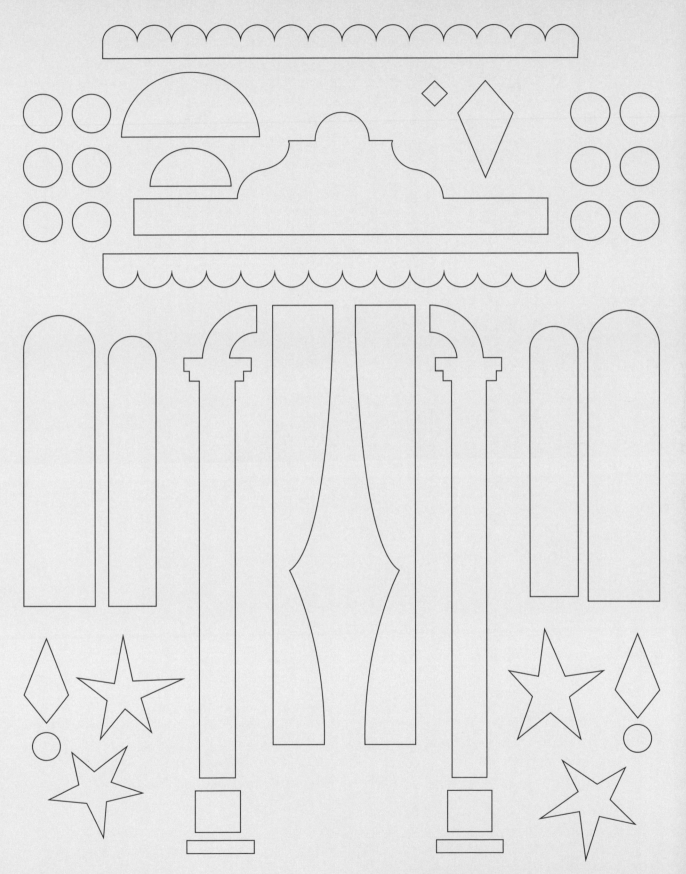

↖ E

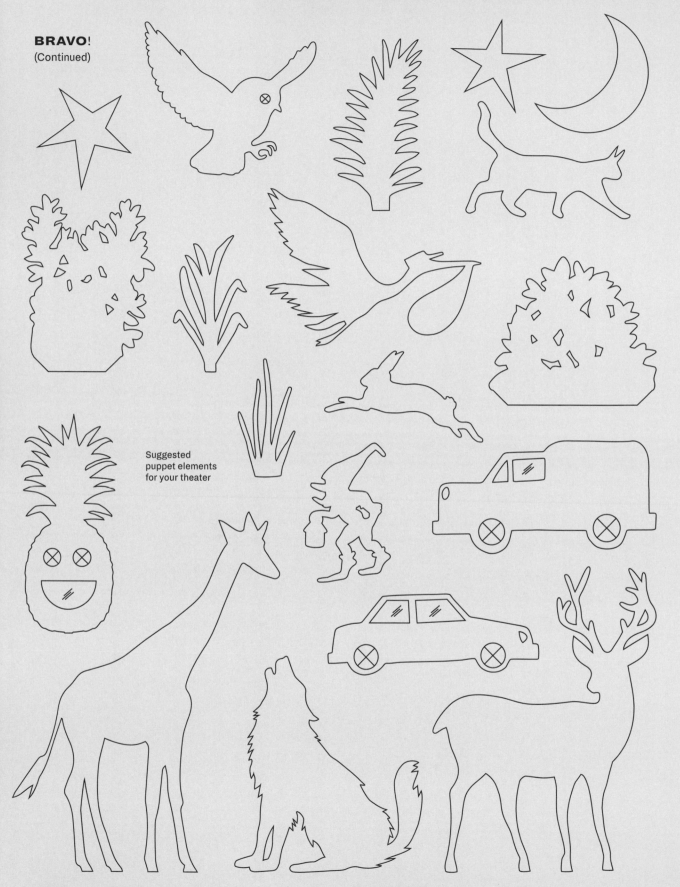

Suggested
puppet elements
for your theater

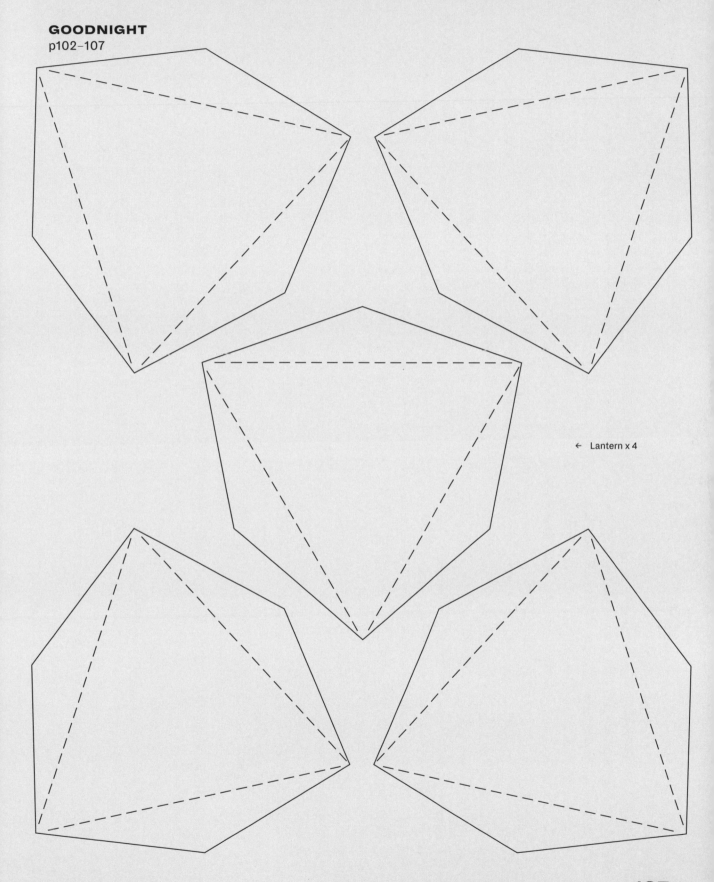

← Lantern x 4

CREDITS

All studio photography by Sun Lee, sunlee.biz except for page 34 Sam Hofman, page 83 Amy Currell, page 92 Ania Wawrzkowicz and page 100 Simon Vinall. All location photography by Hattie Newman unless otherwise indicated. Toolkit drawings by Polytechnic, polytechnic.works and all step-by-step drawings by Hattie Newman.

Page 14 Rosetta Stone courtesy Tudor Antonel Adrian/ Dreamstime.com; page 56 Detail from Art Deco house, Napier, New Zealand courtesy Bruce Jenkins/Dreamstime. com; and page 104 Festival of Light by Di Bao, for Chinese Lantern Festival produced by Hanart Culture.

➜ ACKNOWLEDGMENTS

Thank you Sun for photographing each project so beautifully (and patiently!). Thank you so much Arthur for all the care and attention you put into every page, I couldn't be happier with the design! Thank you Cristina and Poppy, my magical assistants, for helping me bring my ideas to life.

Thank you Alex, Mum, Dad, Rupert, Will, Ellie, and the Sues for your endless support! Finally thank you Natalia and everyone at Ilex for giving me the opportunity to make my first-ever book!